Voices of Scotland

AN EXHIBITION
HELD AT THE GROLIER CLUB
FROM 15 DECEMBER 1992 TO
20 FEBRUARY 1993

Voices of Scotland

A CATALOGUE OF AN EXHIBITION
OF SCOTTISH BOOKS AND MANUSCRIPTS
FROM THE 15TH TO THE 20TH
CENTURIES

CURATED BY

JANET SAINT GERMAIN

NEW YORK

The Grolier Club

1992

Funding for the publication of this catalogue has been provided
in part by the British Council.

ISBN 0-910672-08-3
ISBN 0-910672-09-1

LENDERS TO THE EXHIBITION

THE NATIONAL LIBRARY OF SCOTLAND, EDINBURGH

THE CITY OF DUNDEE DISTRICT COUNCIL LIBRARIES

THE DEPARTMENT OF HUNTERIAN BOOKS AND MANUSCRIPTS,
GLASGOW UNIVERSITY LIBRARY

THE BOSTON PUBLIC LIBRARY

THE JOHN CARTER BROWN LIBRARY AT BROWN UNIVERSITY

THE COLEMAN PARSONS AND SELIGMAN COLLECTIONS, THE RARE
BOOK AND MANUSCRIPT LIBRARY, COLUMBIA UNIVERSITY

THE FOLGER SHAKESPEARE LIBRARY, WASHINGTON, D.C.

THE HOUGHTON LIBRARY, HARVARD UNIVERSITY

THE LILLY LIBRARY, INDIANA UNIVERSITY, BLOOMINGTON

THE PIERPONT MORGAN LIBRARY, NEW YORK

THE NEWBERRY LIBRARY, CHICAGO

THE GENERAL RESEARCH DIVISION OF THE NEW YORK PUBLIC
LIBRARY, THE ASTOR, LENOX & TILDEN FOUNDATIONS

MR. WILLIAM SCHEIDE AND THE SCHEIDE LIBRARY,
PRINCETON UNIVERSITY

THE THOMAS COOPER LIBRARY,
UNIVERSITY OF SOUTH CAROLINA

THE BEINECKE LIBRARY, YALE UNIVERSITY

THE YALE CENTER FOR BRITISH ART

THE LEWIS WALPOLE LIBRARY, YALE UNIVERSITY,
FARMINGTON, CONNECTICUT

THE GROLIER CLUB, NEW YORK

THE EARL OF PERTH

THE VISCOUNTESS ECCLES

MESSRS. KULGIN DUVAL AND COLIN HAMILTON

MR. JOEL EGERER

ELEANOR T. ELLIOTT

MR. KENNETH A. LOHF

PROFESSOR G. ROSS ROY

MRS. PETER SAINT GERMAIN

PREFACE

Since the Grolier Club was founded in 1884 numerous exhibitions have been devoted to Irish and English literature. However, until the current exhibition, "Voices of Scotland," there has been no comprehensive showing at the Club of the treasures of Scottish literature, a lack which the current exhibition now generously fulfills. The more than one hundred and thirty rarities described in this catalogue demonstrate the breadth and vitality of the Scottish achievement in lyric poetry, in the effective use of dialect in the writing of poetry, and in the effect that the vivid background of the Scottish experience, landscape, and history has had in forming the basis for much of the poetry, fiction, and historical and philosophical writing that were written or published during the past five centuries.

Many of Scotland's writers have achieved world fame, among them, the poets and playwrights William Drummond of Hawthornden, William Dunbar, Robert Henryson, Allan Ramsay, James Thomson, Robert Burns, Sir James M. Barrie, Hugh MacDiarmid, and Edwin Muir; novelists Tobias Smollett, Sir Walter Scott, Robert Louis Stevenson, George Macdonald, and John Buchan; and historians and philosophers David Hume, James Boswell, and Thomas Carlyle. These writers, and many of the other significant literary figures of the Scottish and English Wars, the Scottish Reformation, the Civil Wars of the 17th century, and the Scottish Renaissance of the 20th century, as well as the women novelists of the 19th century, are introduced and their works described in their historical context by Janet Saint Germain, who first suggested this exhibition some four years ago and then agreed to become its principal curator. During the interim she produced this catalogue, with the assistance of Iola Haverstick and Rudolph Ellenbogen, and arranged for the loans of important copies from private and public collections in this country and in Scotland, loans for which the Club is enormously grateful. She has also lent extensively from her own personal collection.

The Club is especially grateful to Janet Saint Germain for her exemplary achievement in organizing the exhibition and in writing this catalogue. Finally, it is a pleasure to acknowledge the gift by the British Council in partial support of the publication of the catalogue.

<div align="right">

KENNETH A. LOHF

President

</div>

SCOTTISH LITERATURE

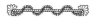

Scottish literature is written in four tongues: Scots dialect, Gaelic, Latin, and English. Several times in the course of Scottish literary history there has been a remarkable flourishing of the national idiom, i.e., the Scots dialect. This periodic resurgence can be attributed to its physical and poetic robustness. Concrete, sardonic, harsh and realistic, Scots is a language that possesses the stamp of the common people, and the finest writers in Scottish literature–Henryson, Dunbar, Douglas, Burns, and Mac-Diarmid (to name just a few)–chose the vitality of the Scots tongue for inspiration. Although there are strong efforts at revival, Gaelic is now a minority language in Scotland. However, it is interesting to note that today excellent prose and poetry continue to be written in Scots and Gaelic as well as in English, bearing out the promise shown by the many fine writers of the "Scottish Renaissance" in the first half of this century.

A unifying element which runs through Scottish writing is its creative tension, the expression of the balancing of opposites inherent in Scottish culture and history. These dynamic qualities of expression are borne from the "zigzag" of contradiction that G. Gregory Smith says is the principal feature of Scottish literature.

As a collector and curator of this exhibition, I would also note that another unifying element which runs throughout is the remarkable level of education represented by the authors, however disparate their backgrounds. Scotland's distinct educational system has stamped its literature with a vivid imprint of democracy.

Who are Scottish writers and what are they saying? This gathering of books and manuscripts is an attempt at

a partial answer. The point of view which underlies this exhibition is that of a collector whose purpose has been to consider Scottish literature as an entity within the context of its historical background.

Without excuse, because the justifications offered by a collector are generally notorious, I must acknowledge my arbitrary choices, the consequent and often regrettable omissions, and the several notable exceptions among this collection of Scottish authors. As an amateur, I offer this catalogue with a measure of trepidation; however, the extraordinary loans which have been made assure a certain substance which it is a pleasure to set forth here.

The Grolier Club gratefully acknowledges the generous grant to this exhibition made by the British Council. It is also a profound pleasure to gratefully acknowledge some of those who have helped me so generously with advice and encouragement. My co-curators, Mr. Rudolph Ellenbogen and Mrs. Iola Haverstick, have been a constant source of help and support. Significant contributions to the writing of this catalogue were made by Lord Perth, Mrs. Iola Haverstick, Mrs. Fletcher Hodges, and by Ms. Elizabeth Muller, who also patiently "computerized" the text, and Kathy Talalay and her editorial expertise. Grolier Club President Kenneth A. Lohf, Exhibitions Committee Chair Martin Hutner, the Club Librarian Martin Antonetti and the Cataloguer Kimball Higgs, and the entire Club staff have done much to facilitate this work and are deserving of especial thanks. For their extraordinary efforts I thank Rachel Doggett of the Folger Shakespeare Library; Anna Lou Ashby, Robert Parks, George Fletcher, and Inge Dupont and the helpful reading room staff at the Pierpont Morgan Library; the kind

staffs of the Lewis Walpole Library and of the Yale Center for British Art; and William Cagle of the Lilly Library who has patiently answered my many questions and has generously shared the wealth of Scottish material in the Lilly Library. G. Ross Roy has contributed his expertise and enthusiasm for Scottish literature as represented in his personal loans and in those from his collection now belonging to the Thomas Cooper Library, as has its librarian, Roger Mortimer. I would also like to extend my warmest thanks to Mr. Rudolph Ellenbogen and his associates at the Rare Book and Manuscript Library of Columbia University, Mr. Stanley Brown of the Baker Library at Dartmouth, Mr. Francis Walker of the Fales Collection at New York University, Librarian Norman Fiering of the John Carter Brown Library, Brown University, and to the solicitous library staffs of the Boston Public Library, the New York Public Library, the Newberry Library in Chicago, the University of Edinburgh, and the Queen Mother's Library at the University of Aberdeen.

I am deeply indebted to those in Scotland who have so generously loaned nothing less than their national treasures. The National Library of Scotland has loaned noble books and manuscripts from their great collections and I am especially grateful to Iain G. Brown for his intitial support and enthusiasm, to Ann Matheson for her great help and to Ian Macgowan, Librarian.

The great universities of Scotland are well represented by the authors displayed here and to Glasgow University I am grateful for their very significant loans; my thanks to David Weston of Special Collections for sharing his expertise in Celtic literature and to Professor Rod Lyell at Glasgow for taking time to talk with a stranger and for his

valuable insights into the field of Scottish literature. Great appreciation is due to the city of Dundee for their generous loan of one of Scotland's greatest literary rarities.

"Thank you" seems inadequate for Lord Perth's generosity in sharing his expertise and for the significant items which he has so kindly lent. Mr. Colin Hamilton is an *éminence grise* here and I thank him and Kulgin Duval wholeheartedly for their unstinting interest and valuable advice. I would also like to thank Professor Kenneth Simpson of the University of Strathclyde who has contributed his valuable knowledge and insight. The Scottish Records Office has freely offered pertinent information as well.

To my husband Peter, and my daughter Janet, my thanks for their infinite patience and enthusiastic support; and I must also end by expressing deepest appreciation to the lenders of the exhibition, who are duly noted herein, for their extravagant generosity.

JANET SAINT GERMAIN
New York, 5 June 1992

THE SCOTTISH AND ENGLISH WARS OF THE FOURTEENTH AND FIFTEENTH CENTURIES

THOUGH much of the writing that evolved out of the rich bardic tradition has been lost, traces of this heritage fortunately still exist in the works of such 12th- and 13th-century authors as Thomas of Ercildoune and John Barbour.

These early writings chiefly reflect Scotland's long struggle against English domination, in particular the persistent efforts of Edward I (1239–1307), known as the "Hammer of the Scots." That Edward and the English failed was largely due to Scotland's legendary heroes Sir William Wallace (1270?–1305) and especially Robert the Bruce (Robert I, 1274–1329) whose conclusive victory at Bannockburn in 1314 not only confirmed Scotland's independence but also served to unite king, nobles, clergy, and common people. Though hostilities were to drag on for years, the nation had been reestablished and redefined. This long struggle resulted in a renaissance in the following century: poets and scholars flourished and three universities were founded at St. Andrews, Aberdeen, and Glasgow.

Michael Scott
(1175?–1234?)

Michael Scott is one of the earliest known writers of Scottish literature. Dubbed the "Wizard," he was a philosopher and astrologer educated at the Universities of Oxford, Paris, and Padua (where there was a thriving school of magic). His studies in alchemy and astrology earned him a reputation as a sorcerer, and through the writings of Dante, Boccaccio, Sir Walter Scott, and James Hogg, he has come down to us as a legendary figure.

Scott enjoyed the patronage of the Pope and was closely associated with the court of Emperor Frederick II at Palermo. He also gained great favor through his translations of Aristotle and his many learned works from the Arabic.

Physionomia. Paris: P. Gaudoul, c. 1520.

First published in 1477, this copy is an apparently unrecorded edition of Scott's popular work on the pseudo-science of physiognomy. The book is dedicated to Emperor Frederick II. Part I is a treatise on the generation, or conception, of human beings; Parts II and III offer digressions on dreams and auguries from sneezes, and show how the soul is dependent for its nature on the body it inhabits; Book III is particularly concerned with explaining that parts of the body such as the eyes, hair, and nails, can indicate virtues and vices of men and women.

PRIVATE COLLECTION

The Declaration of Arbroath (1320)
Facsimile. Edinburgh: The Scottish Records Office. Calligraphy by Marilyn Hodkin, 1992.

The *Declaration of Arbroath* is a letter from the barons of Scotland to Pope John XXII petitioning him not to side with the English against Bruce. The letter emphasizes Scotland's long history as an independent Christian kingdom and dwells on its sufferings since Edward I's aggression. It asserts an entire people's loyalty to King Robert Bruce and their determination never to yield to England but to maintain their freedom at all costs.

The original letter that was delivered to the Pope is lost. The photograph facsimile on display here represents the only surviving contemporary copy, which is kept at the Register House in Edinburgh. A duplicate made for copy, it bears the seals of eight earls and 38 barons of which only 19 seals survive. One seal belongs to a woman, Mary Ramsey: when David, Lord of Brechin, arrived for the sealing ceremony he found that he did not have his own seal with him and substituted his wife's instead.

"One of the masterpieces of political rhetoric of all time," the *Declaration* is also an outstanding example of medieval Latin prose believed to have been written by Bernard of Linton (d. 1333). Abbot of Arbroath and Robert the Bruce's great Chancellor of Scotland, Bernard was also renowned as a Latinist in poetry and prose.

The *Declaration* is revolutionary in placing the abstract notions of liberty and the freedom of individuals above the rights of the mon-

arch. It stands directly in the line between the *Magna Carta* and the *Declaration of Independence*.

PRIVATE COLLECTION

John Barbour
(1316?–1395)

John Barbour, a contemporary of Chaucer, studied and taught at Oxford and Paris. A very distinguished figure of his age, Barbour was an Archdeacon of Aberdeen and an Auditor of the Exchequer. He was also the Auditor of the Household of Robert II. Barbour is known as the father of vernacular Scottish poetry and history. His fame rests on his epic poem, *The Brus*, a careful telling of Robert the Bruce's life. It is grounded in realism or *suthfastnes*. Matthew P. MacDiarmid describes the poet as one who had "long travelled the land collecting material, accounts preserved in castle and abbey, still current lays, the faithful memories of old soldiers and their sons."

The Brus (Advocates MS 19.2.2 [i]), before 1480.

This poem was composed by Barbour between the years 1376 and 1378. It is exceptional for its vivid descriptions, especially those of the Battle of Bannockburn where in 1314 Robert the Bruce decisively defeated the English army of Edward II, confirming Scotland's independence and his title of King.

Barbour's moral throughout is the praise of freedom both national and individual: "A! Freedome is a noble thing!" Robert II, the first of the Stuart kings, recognized the work with a life pension for Barbour.

The Edinburgh manuscript shown here is the work of a conservative scribe and preserves a more archaic stage of the language than another early known copy.

LENT BY THE NATIONAL LIBRARY OF SCOTLAND, EDINBURGH

Walter Bower
(1383–1437)

Walter Bower was born in Haddington and educated at Paris and St. Andrews before being appointed Abbot on the Island of Inchcolm in the Firth of Forth. A prominent figure in politics, Bower was a commissioner appointed to collect the ransom money on behalf of the young James I, held captive in England.

Scotichronicon (Advocates MS 35.1.7), before 1480.

The *Scotichronicon* continued the *Chronica Gentis Scotorum* of the earlier historian, John of Fordun (d. 1385), extending his history from 1383 to 1437 with substantial additions. Bower had access to documents which have since been lost, and the *Scotichronicon* has thus become an important sourcebook for later historians.

Before his death, Bower produced an abridged version of the *Scotichronicon* for readers who wanted a less prolix account. While shortening the work, Bower made numerous textual alterations which are of particular interest to scholars. The manuscript presented here is known as the *Coupar Angus Manuscript* after the abbey in Perthshire where it was once kept. This manuscript was copied from Bower's own revised version some time before 1480.

LENT BY NATIONAL LIBRARY OF SCOTLAND, EDINBURGH

THE REFORMATION AND THE CHURCH OF SCOTLAND

JOHN BUCHAN has observed that "the Reformation came to Scotland in its most drastic form." It was in fact the final breach with Rome. In 1560 John Knox, a follower of Calvin, drew up a Confession of Faith which was ratified by Parliament. That same year the first General Assembly was held and in 1567 the Reformed Church was established by Parliament which disallowed "any other face of Kirk in Scotland." The spirit of worship derived directly from Calvinism; the congregation was self-governing and the aim was the pure preaching of the Word.

Seeds of dissension lay in Knox's conception of the Church as an institution of unlimited authority. It could not choose but interfere in civil affairs. The profound irony of the Church of Scotland is that it gave to the nation the most rigid theocracy along with a radical democracy. Knox decreed that every parish in the land would educate all those who were capable of learning, thus providing for an astonishing rate of literacy among all manner of folk.

Robert Henryson
(1430?–1506?)

Very little is known about Robert Henryson's life except that he was a schoolmaster and may have taught law at the University of Glasgow. His writings demonstrate an acquaintance both with legal vocabulary and the practice of law indicating some kind of higher degree, probably from a European university.

Along with William Dunbar, Henryson is regarded as the greatest of the 15th-century Scots poets or *makars* as they are called. Described as one of the most Chaucerian of the *makars*, Henryson was highly learned–a pure lyrist whose ingenious rhymes and mastery of cadence set him apart. He not only gave a special direction to the ballad but also introduced the moral fable and the pastoral into the Scots language. Henryson was a humanist in the northern European tradition and his philosophical bent shows in his concern with the troubles of the time. In addition to the fables, Henryson is known for his *Orpheus and Eurydice* and *The Testament of Cresseid*.

The Morall Fabillis of Esope, Compylit in Scottis meter.
Edinburgh: T. Bassandyne, 1571.

The only known copy of this edition of Henryson's version of Aesop in Scots, a work generally regarded as his finest. In these fables Henryson uses the plain homely speech of contemporary Lowland Scotland. The book is printed in Granjon's *civilité* type; being the first use of this type in Scotland, it is presumed that it was brought directly from France. Since the middle of the 16th century, most Scottish printers had been using English types, but this *civilité* is a notable exception.

LENT BY THE NATIONAL LIBRARY OF SCOTLAND, EDINBURGH

William Dunbar
(1460?–1520)

Perhaps the most varied and creative of the medieval *makars*, Dunbar offers a variety of moods in his poems, revealing all sides of the human character while still maintaining his own personal and expressive stamp. Much of our knowledge about his life comes from his poems. Evidence suggests that Dunbar was a student at St. Andrews. He became a Franciscan novice but after travelling in England and Picardy, left the order and gained royal favor at court. He was a member of the embassy to England that arranged the marriage of Scotland's James IV to England's Margaret Tudor, daughter of Henry VII.

Even though poverty persisted, occasioning many of Dunbar's complaints and satires, the reign of James IV is seen as a golden age in Scottish history. Dunbar's allegories, influenced by the philosophy of courtly love, call up scenes of great beauty.

In 1513, the disastrous battle of Flodden occurred in which James IV and a great number of his nobles were killed. The English victory resulted in the decimation of Scottish chivalry. Dunbar's poetic expression changed, and he turned to the writing of laments and sacred poems.

The Bannatyne Manuscript (Advocates MS 1.1.6), 1568.

In 1568, when the plague came to Edinburgh, a 23-year-old merchant named George Bannatyne took to his estate outside the city and began copying the poems in his possession, preserved up to that time in

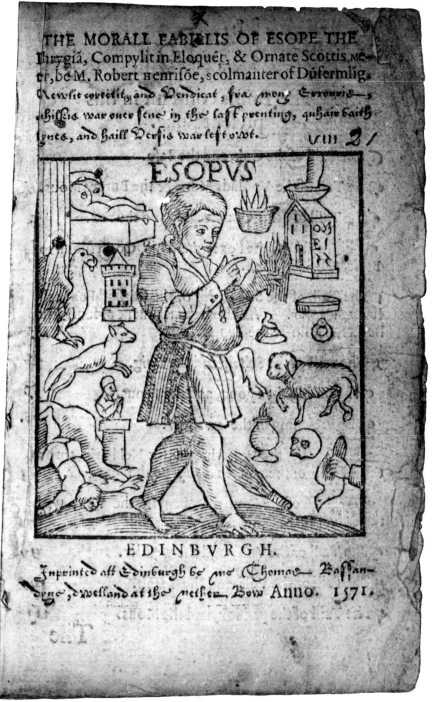

THE MORALL FABILLIS OF ESOPE THE
Phrygiã, Compylit in Eloquét, & Ornate Scottis me-
er, be M. Robert Henrisõe, scolmaiter of Dũfermlig.
Newlie correctit, and Vendicat, fra mony Errouris
quhilkis war over sene in the last prenting, quhair baith
lynes, and haill Versis war left out.

ESOPVS

EDINBVRGH.
Inprintit att Edinburgh be ane Thomas Bassan-
dyne, dwelland at the nether Bow. Anno. 1571.

FIG. 1. Title page of *The Morall Fabillis of Esope* by Robert Henryson.
Courtesy of The National Library of Scotland, Edinburgh.

badly damaged copies. By so doing, he rescued about 450 Scottish poems of the 15th and 16th centuries, of which about 150 would otherwise have been lost, while many others would have survived only in defective texts. In Sir Walter Scott's phrase, Bannatyne accomplished nothing less than "saving the literature of a nation."

Described by Bannatyne as "a most godlie, mirrie and lustie Rapsodie maide by our sundrie learned Scots poets," this invaluable collection is our major source for the poems of William Dunbar, Robert Henryson, and Alexander Scott, as well as lesser-known and unknown *makars*.

The page is open to Dunbar's *Lament for the Death of the Makaris*. Each stanza ends with the timeless refrain from the Office of the Dead: *Timor mortis conturbat me*.

LENT BY THE NATIONAL LIBRARY OF SCOTLAND, EDINBURGH

Boetius
[Hector Boece] (1465?–1536)

The historian was born in Dundee, a son of the Laird of Panbride. He was educated at the Universities of St. Andrews and Paris. As professor of philosophy at Paris, Boece was not only a colleague of Erasmus but also of John Major. Boece and Major taught at Paris and among their pupils were John Knox and George Buchanan, both of whom brought the new learning back with them to Scotland. Boece's friendship with the great scholar Bishop Elphinstone, the founder of King's College, Aberdeen, led to his appointment as first principal for the college.

The Church at Aberdeen was the early center of Scottish history writing. There, in that far northern place between the 14th and 16th centuries, lived and worked John of Fordun, Andrew Wyntoun, Bower, Boece, and Buchanan.

Chronicles of Scotland (MS 527).

Boece's fame rests mainly on his Latin history of Scotland. This history covers events from earliest times to the accession of James III. It was later published in Paris by Badius; priced quite reasonably by the Parisian booksellers, it was a popular work. In contrast to John Major,

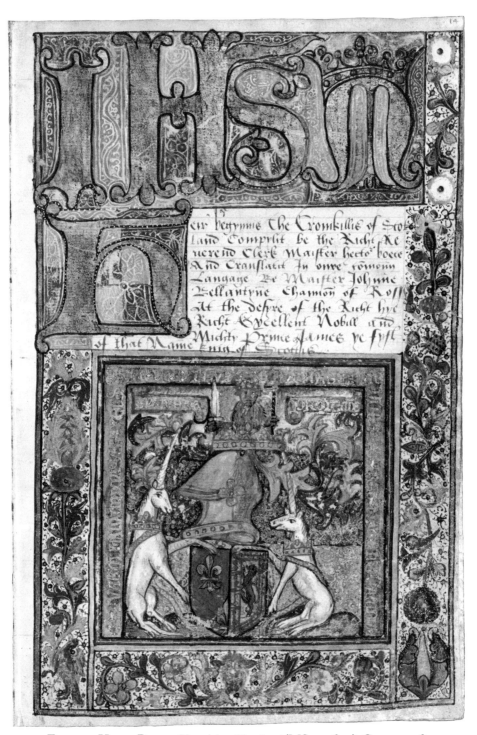

Fig. 2. Hector Boece, *Chronicles of Scotland* (MS 527, f. 14). Courtesy of
The Pierpont Morgan Library, New York.

Boece was a more credulous historian, bound more by tradition than fact. Listed here are the 80-odd kings who ruled Scotland prior to Malcolm Canmore, commencing with Fergus in 330. Much of this material passed into Hollinshed's *Chronicle* which later became a major source for Shakespeare's *Macbeth*.

Shown here is John Bellenden's translation of Boece's history into Scots as requested by James V. Bellenden was Canon of Ross (fl. 1533–1587). Of the nine extant manuscripts of this *Chronicle*, this copy has been called "the finest, most accurate and probably most primitive." It is written in small cursive "be ye hand of Maister David Douglas, notaire public, servitoure to Maister James Douglas, Archidene of Murraye."

LENT BY THE PIERPONT MORGAN LIBRARY, NEW YORK

John Major
(1469–1550)

John Major was thought to have been born in North Berwick and educated at the Universities of Cambridge and Paris. An historian and philosopher of high repute, Major taught at Paris and at Glasgow, and was Provost of St. Salvator's College at St. Andrews. Among his students were the reformers John Knox, George Buchanan, and John Wedderburn, the author of *The Gude and Godlie Ballatis*.

Historia Maioris Britanniae tam Anglie atque quam Scotie. . . . [Paris]: Venundatur Iodoco Badio Ascensio, [1521].

First edition. Acclaimed as the first critical history of Scotland, this book was published by the great humanist scholar-printer, Badius. It was dedicated to the then boy-king, James V of Scotland.

This history is Major's best-known work. It deals with English and Scottish history, revealing the author as a man of broad vision who espoused the union of the two kingdoms. Major was also more factual than many of his contemporaries and less likely to draw upon legend. His political view was based on his belief that authority was vested in the people and not in kings.

PRIVATE COLLECTION

Gavin Douglas

(1474?–1522)

A son of Archibald Douglas, fifth Earl of Angus and one of the most powerful nobles in the land, Gavin Douglas studied at St. Andrews and possibly at Paris. As a scholar, Douglas was an associate of the influential schoolman, John Major. He also enjoyed the benefits of court patronage throughout his life, rising through the ranks of the Church to become Bishop of Dunkeld, a post of influence and power.

After the defeat at Flodden in 1513, Douglas' nephew married Margaret Tudor, the widow of James IV, and from that point on Douglas' fortunes were tied to the Queen's party. Imprisoned during the political upheavals of the Duke of Albany's regency, Douglas later regained favor and went on the mission to France that arranged the marriage of James V to a daughter of Francis I. Douglas' continued involvement in the power struggles of the Scottish nobility resulted in his exile to England where he died in London of the plague.

The Palis of Honoure, compyled by Gawyne Douglas Bysshope of Dunkyll. London: William Copland, [1553?].

Douglas completed *The Palis of Honoure* in 1501. The earliest known edition is this undated one published by William Copland, most likely in 1553. It is dedicated to James IV. There may have been an earlier edition—although no copy has been found—since Florence Wilson imitated the poem in his *De Tranquillitate Animi* which appeared in 1543.

The Palis of Honoure, influenced by the *Roman de la rose*, is in the tradition of courtly allegory. The poem reflects Douglas' knowledge of Latin and Italian poetry. Its central theme is the nature of honor and its attainment.

LENT BY THE LILLY LIBRARY, INDIANA UNIVERSITY, BLOOMINGTON

The XIII Bukes of Eneados of the famose Poete Virgill translatet out of Latyne verses into Scottish metir. . . . London: [William Copland], 1553.

This copy was formerly in the library of the Marquess of Bath at Longleat.

Douglas' fame as a poet rests ultimately with the *Eneados*, his great

translation of Virgil's *Aeneid* into Middle Scots. As did Chaucer, Douglas expanded the existing boundaries of his native language. Douglas lists three justifications for the translation: to encourage the use of the Scots language, to communicate to a wide audience, and to disseminate Virgil's work to a broader public. Douglas' prologues contain some of his finest and most original poetry. This is one of literature's great *tours de force*. Douglas dedicated this work to his cousin Henry, Lord Sinclair, the captain of James IV's warship, the *Great Michael*.

PRIVATE COLLECTION

Sir David Lindsay of the Mount
(1490?–1555)

Sir David Lindsay was the eldest son of an estate owner in the Howe of Fife. He may have studied at St. Andrews. After his education he was attached to the court of James IV. As Gentleman-Usher, Lindsay tended to the young Prince James, later James V. After the death of James IV, however, and the subsequent rise of the Douglas family at court, Lindsay was banished to his country estate. When James V attained his majority, Lindsay was restored to favor and knighted. Created Lyon King of Arms, he was in charge of heraldry and became the King's emissary to France, Spain, and England.

Lindsay composed the first great play in Scottish drama, *Ane Pleasant Satyre of the Thrie Estaitis*, for the marriage of James V to Mary of Guise (1515-1560). The author's mouthpiece, "John the Common Weill," speaks for the ordinary man and woman; he bemoans the laziness, falsehood, pride, and greed into which Scotland had fallen. The play ends with an exhortation to the King to remember the importance of his high office, a recurring motif in Lindsay's work.

Lindsay's enduring popularity rests on his integrity. Although a Roman Catholic in practice, he was a reformer by inclination and became an early supporter of John Knox.

A Dialogue betweene Experience and a Courtier, of the miserable state of the Worlde. . . . London: Thomas Purfoote, 1575.

This is the second English edition of Lindsay's mature philosophical considerations, first published in 1566.

PRIVATE COLLECTION

Aberdeen Breviary
[Breviarij Aberdonensis ad per celebris ecclesiae Scotorum usum (pars hyemalis, pars estivalis)]. Two volumes. Edinburgh: W. Chepman, 1509–1510.

Intended to supercede the Sarum Breviary, this book was responsible for the introduction of the art of printing into Scotland. The driving force behind its production was William Elphinstone, Bishop of Aberdeen, who personally supervised the printing, undertaken at the command and expense of the Edinburgh merchant, Walter Chepman. The absence in both volumes of his partner's name, Andrew Myllar, is puzzling, but it is generally thought that Myllar must have been involved at some stage in the supervision of the printing house. In fact, Chepman and Myllar were issued the first printing license in Scotland (1507) by James IV (1473–1513). It was their partnership that in 1508 produced the first printed matter in Scotland. This Breviary is the most important work to issue from the first Scottish press, and the most substantial to survive to the present day. All surviving copies are imperfect.

LENT BY THE NATIONAL LIBRARY OF SCOTLAND, EDINBURGH

George Buchanan
(1506–1582)

George Buchanan was born on a farm in Stirlingshire. His father died when Buchanan was a child, leaving his wife Agnes and their eight children in poverty. Buchanan's aptitude in the local grammar school was such that an uncle sent him to study in Paris. Returning to Scotland, where his name appeared as a pauper student at St. Andrews, he studied under John Major, and finally completed his education in Paris. Buchanan then taught on the continent where he also wrote four major plays in the classical style. One of the students taking part in these productions was Montaigne.

When Scotland came under the Reformers' influence, Buchanan returned home and became principal of St. Leonard's College at St. Andrews. Despite his Protestant tendencies, he was appointed tutor to Mary, Queen of Scots. He was a member of her privy council and an eloquent admirer. His admiration for the Queen ended with the murder of her cousin and husband, Henry Stewart, Lord Darnley (1545–1567), and with her hasty marriage to James Hepburn, Earl of

Bothwell (1535?–1578). Henceforth, Buchanan was her deadly opponent. Between 1570–1578, Buchanan was the tutor to the young James VI at Stirling, raising the boy to be a good Protestant and to despise his mother. Buchanan became an active participant in the new Presbyterian Church. In 1587, he was elected Moderator of its General Assembly. He wrote scurrilous accusations against Mary, testifying against her at her trial in England where the famous "casket letters" were produced as evidence implicating Mary in Darnley's murder. It was Buchanan and Mary's secretary, William Maitland, who identified the handwriting in the letters as Mary's, thus ensuring her continued imprisonment and eventual execution.

"Buchanan was a renowned scholar, an outstanding writer of Latin prose, and the leader of a considerable school of Latin poets in Scotland. He also played an important role in providing an intellectual backbone to the Reformation movement in Scotland" (Royle).

In addition to the books displayed here, Buchanan is noted for his *Rerum scoticorum historia* and *De sphaera*, an attack on contemporary science.

PRIVATE COLLECTION

De jure regni apud Scotos, dialogus. [London: E. Aggas] ad ex J. Rossei, Edinburgi, 1580.

Second edition. Buchanan's chief prose work, *De jure*, was written to justify Mary's dethronement. It enjoyed a substantial reputation among European reformers.

LENT BY THE PIERPONT MORGAN LIBRARY, NEW YORK

Paraphrasis Psalmorum Davidis Poetica. . . . Argentorati: Excudebat Iosias Rihelius, 1568.

An early edition of Buchanan's famous Latin paraphrases of the Psalms. Originally composed in 1549 when Buchanan was imprisoned at Coimbra in Portugal by the Inquisition, it was first published in Paris by Robert Estienne in 1566. This copy was printed two years later at Strasbourg; it retains the celebrated 12-line dedicatory poem of praise to Mary, Queen of Scots, *Nympha Caledoniae*, which Buchanan had composed before he became the Queen's inveterate enemy.

PRIVATE COLLECTION

John Hamilton
(1511?–1571)

A natural son of the first Earl of Arran, John Hamilton became a Benedictine monk when still a boy. With the support of James V, he became Abbot of Paisley before leaving Scotland to study in Paris. He returned to become Keeper of the Privy Seal, then Bishop of Dunkeld. When Cardinal Beaton was murdered in 1546, Hamilton succeeded him as Archbishop of St. Andrews and Primate of Scotland. Later he was appointed Treasurer of the Realm.

If Hamilton's *Catechisme* was tolerant, his persecution of heretics was not. Nor was the piety of that work evident in his personal life. On a more positive note, he endowed St. Mary's College at St. Andrews and provided funds for its completion.

Hamilton was an avid supporter of Mary, Queen of Scots. A member of her privy council, he baptized her son who later became James VI.

The Queen's troubles were his and Hamilton was accused of complicity in the murders of the Queen's Consort, Henry, Lord Darnley (1545–1567) and of Mary's half-brother, James Stewart (1531?–1570), the Earl of Moray and Regent for Mary's young son James. The Cardinal was hanged in his episcopal vestments at Stirling.

The Catechisme. . . . [St. Andrews: John Scot, 1552].

First edition. The first book printed at St. Andrews by John Scot in 1552, this is a fine example of black letter press. With scarcely a dozen copies known to exist throughout the world, this work is now considered extremely rare.

The Catechisme was an attempt to revive a faith that was in decline because of corruption in the Church. Written in Scots, it was meant to be read from the pulpit and to reestablish the position of the Church. The work is not only notable for its moderate tone but also for its significant silence on the subject of papal supremacy. It failed, however, to arrest the swift decline of Catholicism within Scotland.

LENT BY THE LILLY LIBRARY, INDIANA UNIVERSITY, BLOOMINGTON

John Knox
(1505–1572)

John Knox has been described by John Buchan as "one of the greatest destructive forces in our history and no mean constructive one, a man of immense shrewdness and practical wisdom, but he had little power of coherent thought. An inconsistent writer and speaker, his mind was constantly in a state of confusion."

Knox was born in Haddington, East Lothian. He was probably educated at the University of St. Andrews, studying under John Major. He was ordained a priest, but shortly afterwards transferred his allegiance to the Protestant faith. One of a small group of rebels captured by a French force, Knox was pressed into service as a galley slave in 1547. Two years later he was released and began his reformation work in England, and then in Europe. The catalyst for Knox's development was his stay in Geneva where he worked with John Calvin. Here he formulated many of the doctrines, such as original sin, predestination, and the concept of the Elect, which later formed the basis of Scottish Presbyterianism.

Deeming the time to be ripe, Knox returned to Scotland in 1559. He preached a violent sermon at Perth that led to the destruction of many Catholic churches and monasteries and sparked a general Protestant revolt. Knox was invited to be the minister of St. Giles, the principal church in Edinburgh. He held this position until his death in 1572.

Surely his greatest achievement was his contribution to *The Book of Discipline* which advocated in 1561 the establishment of a national system of education from parish schools to universities.

The First Blast of the Trumpet against the Monstrous Regiment of Women. [Geneva: J. Crispin], 1558.

First edition. One of the best-known and most controversial books ever to come from the pen of a Scottish writer, this book was first printed in Geneva anonymously and without the name of the printer or place of publication; indeed, no record of its publication was kept by the syndics of Geneva in their Register of Permits. The author's central argument focuses on the unfitness of women to wield power. More specifically, Knox was aiming his diatribes at the respective rulers of England and Scotland, Mary Tudor (1516–1558), and the Queen Regent, Mary of Guise (1515–1560), whom he doubly viewed

as his enemies by virtue of their sex and staunch support of Roman Catholicism. Waiting in the wings were, again respectively, Gloriana herself, Elizabeth I of England (1533–1603) and Mary, Queen of Scots (1542–1587). Not a Prince in sight! Poor Knox!

LENT BY THE FOLGER SHAKESPEARE LIBRARY, WASHINGTON, D.C.

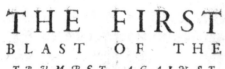

THE FIRST
BLAST OF THE
TRVMPET AGAINST
THE MONSTRVOVS
regiment of
women.

Veritas temporis filia.

M· D· LVIII·

FIG. 3. Title Page of *The First Blast of the Trumpet* by John Knox. Courtesy of the Folger Shakespeare Library, Washington, D.C.

The first [seconde-thirde] Book of the History of the Reformation of Religioun within the Realme of Scotland. [Thomas Vautrollier, 1587].

This is the first edition of Knox's principal work. Unfinished, it was printed in 1587 and was promptly seized and suppressed. The completed edition of five books appeared in 1644.

LENT BY THE PIERPONT MORGAN LIBRARY, NEW YORK

The Preaching of John Knox before the Lords of the Congregation
George Thomas Doo (1800–1886) after Sir David Wilkie (1785–1841)
Engraving, 1838
52.7 x 72.3 cm. (20¾ x 28½ in.)
LENT BY THE YALE CENTER FOR BRITISH ART, THE PAUL MELLON
COLLECTION

The Wedderburn Brothers:
James (1495?–1553), John (1500?–1556),
and Robert (1510?–1557)

The three brothers were the sons of a prosperous merchant in Dundee. All were graduates of St. Andrews where John had come under the teaching of John Major and was an early recruit to a group of reformers centered there. James became a merchant; John and Robert took holy orders. Under suspicion of heresy, all three ardent reformers were forced to flee abroad. In exile, the Wedderburns were introduced to the hymnody of the German and Swedish reformed churches which greatly influenced their future work, *The Gude and Godlie Ballatis.*

Ane Compendious Buik of Godlie Psalmes and Spiritual Sangis. With Diueris Utheris Ballatis. Edinburgh? John Scot? 1567.

Title missing. This is the only known copy of the 1567 edition of this major landmark of the Scottish Reformation. Until recently, it was thought to be the earliest known copy; however, a copy from 1565 has been found in the University Library at Göttingen.

Commonly known as *The Gude and Godlie Ballatis*, this earliest known metrical treatise in Scots is the collection of sacred songs and ballads which was to prove so effective in spreading the doctrines of

the Reformers throughout Lowland Scotland. Many of the songs were adapted from older folk poems and verses of courtly love and set to secular tunes. This combination of the sacred and the profane added to the enormous popularity of the work, which was in constant use throughout the 17th century, and is an early indication of the coarseness and refinement that was to characterize so many of the best collections of traditional Scottish songs.

It is likely that many of these songs were first circulated by the Wedderburns as broadsheets in the 1540s before being published by John Wedderburn and John Scot, a printer in Dundee (fl. 1550). Several acts of Parliament were passed which forbade the publication of this work.

LENT BY THE CITY OF DUNDEE DISTRICT LIBRARIES

John Leslie
(1527–1596)

Referred to by Knox as a *priest's gett* (bastard), Leslie was the natural son of a priest in Inverness-shire. He was educated at Aberdeen, Toulouse, Poitiers, and Paris; became an official in the diocese of Aberdeen, and was made a Doctor of Canon Law there at King's College. In 1560, he was named by the Lords of the Congregation as one of two Catholics to debate points of belief with two reformers, one of whom was John Knox.

On the death of Mary Stuart's first husband, King Frances II, Leslie visited the Queen in France at the behest of Huntley and other Catholic nobles in the north. Leslie became the Queen's close confidant and supporter. As Queen of Scots she appointed him Lord of Session in 1564 and then Bishop of Ross. After her downfall, Leslie continued to support the Queen's cause both in Scotland and abroad. With his estates in Ross forfeited, he lived in France and was granted the bishopric of Coustances. Leslie founded Scots colleges at Rome, Paris, and Douay.

His writings on behalf of the Queen represented the opposite perspective to that of Buchanan. "If not endowed with such brilliant rhetorical gifts as Buchanan, and if destitute of his skill in bitter invective, he was at least his equal in dialectics and excelled him in legal learning" (DNB).

Lesley, Eveque de Rosse

Pieter van Gunst (1667–1724) after Adriaan Van der Werff (1659–1722)
Engraving
31.9 x 18.4 cm. (12⅜ x 7¼ in.)

LENT BY THE YALE CENTER FOR BRITISH ART, THE PAUL MELLON
COLLECTION

De origine moribus, et rebus gestis Scotorum, libri decem.
. . . Rome: In aedibus populi Romani, 1578.

First edition. Originally written in Scots when Leslie was confined to
the Tower of London for a time. The history was written for Mary, to
whom it was presented in 1571. Leslie went on to translate his history
into Latin which was then published in 1578. Considered to be inaccu-
rate, it does contain a vivid and intimate picture of the Reformation
from a Catholic point of view.

This copy is open to a woodcut portrait of Mary, Queen of Scots,
and her young son, Prince James, who later became James VI of Scot-
land and James I of England.

PRIVATE COLLECTION

Robert Rollock
(1555?–1599)

Robert Rollock was the son of a Stirlingshire laird. Rollock excelled in
his studies at St. Salvator's College at St. Andrews. In 1583, the town
council of Edinburgh appointed him sole regent of the newly founded
College of James VI, later known as the University of Edinburgh.
Rollock taught philosophy and theology and won recognition for his
humanist scholarship. He remained first principal of the University
after becoming an ordained minister.

The majority of Rollock's works are commentaries on scripture; they
are the earliest examples we have of this genre in Scottish literature.

Tractatus de vocatione efficaci. Edinburgh: Excudebat
Robertus Waldegrave Typographus Regius, 1597.

This book on religious vocation was later translated into English as *A
Treatise of God's Effectual Calling* (1603). It is dedicated to James VI,
and this copy is open to the royal arms. Note the ancient form using

the unicorn and the dragon. (It was the 12th-century King William the Lion who substituted the lion for the older dragon; it is very unusual to see the dragon rampant.)

PRIVATE COLLECTION

James VI of Scotland and I of England
(1566–1625)

The contemporary French statesman Sully described James as "the wisest fool in Christendom." The ungainly offspring of a tragic alliance (Mary, Queen of Scots and her cousin Henry, Lord Darnley), James was separated from his parents in infancy and taught by his tutor, George Buchanan, "to regard his mother as the murderess of his father, an adulteress who had deserted him for her lover, and last of all, the protagonist of a wicked and heretical religion" (Fraser). James grew up to be a serious, scholarly, withdrawn and complicated individual, concealing a high intelligence and political shrewdness beneath a veneer of coarseness, timidity, and buffoonery (Cherry). With the forced abdication of his mother in 1567, the infant James was named King.

Of the Stuart kings, James VI was the most prolific writer. He saw himself as the "schoolmaster" of the Realm, writing treatises on demonology, the evils of tobacco, and a variety of other subjects. Despite his rigidly Calvinist education, against which he rebelled, theology became a lifelong passion. James translated the Psalms of King David (with the participation of Sir William Alexander and William Drummond), but his greatest contribution was to encourage a new translation of the Bible. This noblest monument of English literature was completed in 1611 and the fulsome praise of the King in its dedication was not undeserved, as James had taken a close interest in every stage of the undertaking.

Similarly, he involved himself in the founding and running of many educational institutions. His scholarly connections were such that when he travelled to Denmark to marry his Queen, Anne of Denmark, he visited the great astronomer Tycho Brahe at his island castle and observatory at Uranienborg. The King marvelled at Tycho's work in a poem of commemoration. Tycho presented James with his study of the comet of 1577, and Tycho's assistant and successor, Johannes Kepler, dedicated his pivotal work, *De harmonia mundi*, to the King.

The Essayes of A Prentise, in the Divine Art of Poesie. Edinburgh: Thomas Vautroullier, [1585?].

The Essayes is James VI's first published book. It includes not only verse but a "Schort Treatise" in which the ever-didactic author sets forth rules and advice that prompted C. S. Lewis to remark: "What keeps James right is . . . the great Scotch tradition which he inherits. . . . James is, in fact, a good 'prentise' who has had good masters and attended to them."

Not considered to be a major poet, James VI nevertheless wrote a substantial body of poetry, much of which showed a French influence. He was at the center of his court poets who were known as the Castalian Band. James followed the example of two earlier Stuart kings, James I (1394–1437) and James V (1512–1542), both of whom were also poets.

LENT BY THE PIERPONT MORGAN LIBRARY, NEW YORK

Βασιλικον δωρον, *Or His Majesties Instructions to His Dearest Sonne, Henry the Prince.* London: Printed by Felix Kyngston for John Norton, 1603.

The first London edition. This book was first privately printed, in 1599, in Edinburgh, in an edition of seven copies. This copy is reputed to have belonged to Charles I and the initial on the verso of the flyleaf is said to be that of James VI.

Being almost the first of the numerous "courtesy" books, this book enjoyed extraordinary popularity. When it was written, the idea of a gentleman in the modern sense was still being formed, and there was avid interest in the King's instructions on manners and morals. Today, the book's interest lies more in James's political advice based on the divine right of kings.

Prince Henry, the recipient of his father's instructions, died in 1612 at which time his brother Charles became Prince of Wales. As King, Charles I took his father's advice very seriously.

LENT BY THE PIERPONT MORGAN LIBRARY, NEW YORK

THE CIVIL WARS

A T T H E E N D of the 16th century, the Scottish Church abolished the title of Bishop and then the Episcopal Church itself, thereby creating a division between the Church of England and the Church of Scotland. "So we reach what is sometimes known as the Second Reformation, which was a revolt from Prelacy, as the First Reformation had been a revolt from Rome" (Buchan). In Scottish history, Presbyterianism represented freedom and the rights of the middle and lower classes against the crown and the aristocracy. Had it not been for the opposition and persecution carried on by the Stuart kings, the Presbytery might have proven less entrenched and more willing to compromise.

For the better part of a century, the wars which raged in England between king and parliament were played out in Scotland as a bitter religious struggle between the crown and the people. Murderous clan warfare added to the evil of the time. Scotland, riven by faction, became a slippery slope upon which many a great man was toppled.

THE UNION OF THE CROWNS: 1603

At the end of her long life, the childless Queen Elizabeth I acknowledged King James VI of Scotland as her successor, thus uniting the two kingdoms. However, the two nations continued as distinct entities, each retaining its own parliament and judicial and educational systems. When King James VI of Scotland moved to London as James I, he found himself free of all the constraints which the Scottish Kirk had imposed on him. He immediately sought to assimilate the Churches of Scotland and England. In so doing he hoped to put an end to the meddling of the Presbyterian clergy in civil matters.

Charles I
(1600–1649)

A Large Declaration Concerning the Late Tumults in Scotland.... London: Printed by Robert Young, His Majesties Printer for Scotland, 1639.

First edition. This is an apologia of court proceedings in church matters. The narrative argues the King's view and denounces the "sedi-

tious practices of the Covenanters." The *Declaration* was in turn denounced by the Scots Parliament as "incendiary."

Despite the authorship stated on the title page, the *Declaration* was written by Walter Balcanquhall (1586?–1645) who was convinced of King Charles I's views on episcopacy. He was born in Edinburgh and attended university there. Balcanquhall later studied at Oxford and rose through the ranks of the Church of England to become the Dean of Durham. He was admired as a man of integrity and ability.

PRIVATE COLLECTION

William Alexander, Earl of Stirling
(1567–1640)

This noted poet and statesman was brought up on his small estate near Stirling. He was educated there and at the Universities of Glasgow and Leiden. Alexander became tutor to the seventh Earl of Argyll who introduced him into the court of James VI in Edinburgh. Alexander then became one of the court poets who banded around the King. His position as tutor to the King's eldest son, Prince Henry, inspired his *Paraenesis* and four tragedies. "His was an astounding audacity of council and an articulate assertion that wicked princes may be dethroned. . . . Manlier speech never was addressed to kings than by him . . ." (DNB). With the untimely death of Prince Henry at the age of 18, Alexander took up another influential post in the household of Prince Charles.

Alexander's social and political position increased with the court's move to England in 1603. In 1621, James granted him jurisdiction over the plantation of Nova Scotia, designed as an area of Scottish colonization. At one point, a very large section of North America and Canada came under his sway. Alexander was made Secretary of State for Scotland, was created Earl, and was named a judge of Scotland's supreme court of law, the Court of Session.

Alexander is deemed a great man, if not a great poet. His contemporary and close friend, William Drummond of Hawthornden, was Alexander's superior in poetry. His detractor was Sir Thomas Urquhart who in his book, *The Jewel*, is bitterly sarcastic toward his fellow countryman: "He was born a poet and aimed to be a king." In fact, Alexander died insolvent. "His noble poverty is the best vindication of his integrity" (DNB).

Aurora. Containing the first fancies of the authors youth. London: Printed by Richard Field for Edward Blount, 1604.

The first edition of William Alexander's first book of poetry, sonnets, and songs, celebrating an early love. The inspiration was a genuine but unrequited passion.

The work is dedicated to Lady Agnes Douglas, Countess of Argyll.

PRIVATE COLLECTION

William Drummond of Hawthornden
(1585–1649)

Drummond was the outstanding poet of his century and the one who most anticipated the Enlightenment. Writing a century before that era, Drummond displayed a detailed knowledge of the physical and intellectual achievements of his time. His poems are rich in the imagery of the stellar and planetary universes, reflecting his ambivalence toward such revolutionary theoreticians as Copernicus.

Drummond was born at the family seat Hawthornden near Edinburgh. His father was a Gentleman-Usher to James VI. After university at Edinburgh, Drummond studied law in France but returned to a literary life, surrounded by the books in his substantial library. He was close to the court before it left Scotland in 1603; two of his best friends were Sir William Alexander and Ben Jonson.

Drummond's later life was clouded by poverty and the effects of civil war. Although he signed the *National Covenant*, his sympathies lay with the Royalists and he wrote a scathing satire of the Covenanting zealots. He turned to writing history, and was responsible for the invention of "16 wonderful engines of war."

Masson suggests in colorful prose the view Drummond held at the end of his life: "In 1649, the very climax of disaster and horror seemed to have been reached. The King of Great Britain amid the outcries and protests of the mass of his subjects, and with Europe looking on aghast, brought to a public death; an armed democracy in possession of England; the very form of rule that one had always detested and dreaded most, a rule of a few nobles coerced by a thousand priests, riveted upon Scotland! It was as if one had lived all this while only to see the elements confounded, the Earth's basis loosened, the heavens hung with black. Drummond could not have foreseen that eventually the new philosophy, which had excited and depressed him . . . would

help to produce some of the changes he had advocated. Even if he had, he might have thought the cost too high."

Hawthornden Castle, near Edinburgh

Alexander Nasmyth (1758–1840)
Oil on canvas, c. 1820–1822
45.5 x 61 cm. (18 x 24 in.)
William Drummond's ancestral home.

LENT BY THE YALE CENTER FOR BRITISH ART, THE PAUL MELLON
COLLECTION

Poems. London: Printed by W.H. and are to be sold in the Company of Stationers, 1656.

An elegant stylist, Drummond is chiefly remembered for his *Poems* of 1616. The volume exhibited is the first edition of Drummond's collected poems. Included are his Petrarchan sonnets and songs, the religious poetry of *The Flowres of Sion*, his elegy for Prince Henry, and his welcoming "entertainments" for the returns of James VI to Scotland and Charles I. That a poet of Drummond's calibre should write almost entirely in English is indicative of the decline in the vernacular which was not to see a revival until the 18th century.

LENT BY THE PIERPONT MORGAN LIBRARY, NEW YORK

The Booke of Common Prayer and Administration of the Sacraments. And other parts of divine Service for the use of the Church of Scotland. Edinburgh: Robert Young, 1637.

First edition. Charles I, with the encouragement of William Laud, Archbishop of Canterbury, was determined to continue the policy of his father, James VI and I, in restoring episcopacy to Scotland, despite vehement opposition there. Charles lacked his father's moderation, however, and antagonized large segments of the Scottish people. After his first visit to Scotland in 1633, Charles I decided, by an act of pure autocracy, to impose a new prayerbook for use in Scotland.

At its first reading, this most controversial and sublime liturgy provoked a riot in St. Giles Cathedral in Edinburgh. Jenny Geddes, a woman in the congregation, stood up and flung her stool at the bishop, declaring, "Ye'll no say mass in my ear!" Opposition was both violent and widespread and led to the signing of the *National Cov-*

enant in 1638 and ultimately contributed to the outbreak of civil war in 1641.

PRIVATE COLLECTION

The National Covenant of Scotland (Scheide MS 124), 1638.

One of the original covenants signed by the Covenanters in 1638. "Written by John Laurie, writer in Edinburgh" on vellum, it bears 48 signatures including the Earls of Argyll, Rothes, Montrose, Cassillis, Lothian, Wemyss, and others.

Having defeated the efforts by the King and Archbishop Laud in the previous year to impose the English prayerbook on Scotland and fearing further measures by the King, certain Scots thought to revive the *National Covenant* of 1581 that had denounced the Pope and Roman Catholic doctrines. Additional clauses to suit the special circumstances of the time were added to the document. The subscribers engaged by oath to maintain religion as it had existed in the state in 1580, and to reject all innovations since, while still professing loyalty to the King. The Covenant, a temperate and legal assertion of the autonomy of the national Church, was adopted and signed by a large gathering in Greyfriar's Churchyard, Edinburgh, in February 1638, after which copies were sent throughout the country for additional signatures. The copy shown here bears the determination of the city of Glasgow.

Later in the year, a General Assembly held at Glasgow, formally illegal, but composed of ardent Covenanters and with a solid nation behind it, decreed the abolition of Episcopacy, and in 1640 the Covenant was adopted by Parliament.

LENT BY THE SCHEIDE LIBRARY, PRINCETON UNIVERSITY

John Sage
(1652–1711)

The Case of the Present Afflicted Clergy in Scotland, Truly Represented. London: Hindmarsh, 1690.

First edition. Written or compiled by John Sage, a Scottish bishop, this work was published anonymously although its authorship was well-known at the time. Sage was born in Fifeshire of an ancient family. He was educated at St. Andrews and ordained to the ministry.

Driven from Glasgow by the Cameronians, an extremist group of Covenanters, Sage took up his pen on behalf of the persecuted Episcopal clergy. Several of their personal accounts of suffering are included here.

He was banished from his ministry in Edinburgh and literally took to the hills, hiding out in the Angus glens. In 1705, Sage was privately consecrated in Edinburgh as a non-juring bishop.

PRIVATE COLLECTION

Archibald Campbell, Marquis of Argyll and Eighth Earl

(1607–1661)

Having obtained vast territorial possessions over the years, the Campbells of Argyll achieved such great power that their chiefs, known as *MacCollum Mor*, acted as kings in their own west country.

A signatory to the Covenant, Argyll was an extremely able man who maneuvered his way shrewdly between King and Covenanters. He supported joint action on the part of both parliaments as the only safe course for both the cause of the King and that of the people.

The regicide of Charles I caused universal horror throughout Scotland and destroyed any possibility of a close union between the parliaments. Other factions came to the fore, not the least of which was that of Oliver Cromwell, who overturned Argyll's policies. When the scheme to recall Charles II failed, Argyll was discredited and suffered political and financial ruin. He was beheaded in Edinburgh and his head was placed on the same spike at Tolbooth Prison that had once held the head of his great enemy Montrose.

Instructions to a Son. London: Printed and Sold by Richard Baldwin, 1689.

First edition. Argyll wrote these *Instructions* while in prison awaiting his execution. The author gives a pathetic description of his downfall: "My thoughts became distracted and myself considered so many difficulties that all remedies that were applied had the quite contrary operation."

But even while contemplating his own end, the author had the good sense to advise his son to "think no cost too much in purchasing rare Books; next to that of acquiring good Friends I look upon this

purchase; but buy them not to lay by, or to grace your library, with the name of such a Manuscript, or such a singular piece, but read, revolve him, and lay him up in your memory where he will be far the better Ornament."

LENT BY THE LILLY LIBRARY, INDIANA UNIVERSITY, BLOOMINGTON

George Wishart
(1599–1671)

George Wishart (not to be confused with the reformer-martyr of the same name) began his career as a member of the Episcopal clergy at St. Andrews. Here he met John Graham, fifth Earl and first Marquis of Montrose (1612–1650), with whom his life was to be closely linked.

At first a devoted supporter of the Covenant, Montrose became distrustful of the Presbyterians' power. He was won over to the King's side and served as Lieutenant-General in Scotland where he raised the Highland clans for King Charles I, who later created him Marquis of Montrose. A spectacular series of victories over the Covenanters culminated in his triumph at Kilsyth in 1645. Montrose, by now master of Scotland, set about freeing the persecuted members of the Episcopal Church. Wishart, who had been imprisoned in the Thieves' Hole in Edinburgh's Tolbooth Prison, became chaplain to Montrose and travelled with his army. When Montrose was defeated by the Covenanters at Philiphaugh in September 1645, Wishart shared his exile on the Continent.

Montrose, however, returned to Scotland in 1650 to avenge the execution of Charles I. Shortly after his arrival, Montrose was captured and taken to Edinburgh where he was hanged without trial as an outlaw. George Wishart wrote the life of this poet, warrior, and statesman—the greatest of the cavaliers.

Wishart returned to Scotland in 1662 after the Restoration and was consecrated Bishop of Edinburgh.

I.G. De rebus auspiciis serenissimi, & potentissimi Caroli dei gratia Magnae Britanniae, Franciae & Hiberniae Regis, &c. sub imperio illustrissimi Jacobi montisrosarum Marchionis, comitis de Kincardin, &c. . . . Interprete A.S. [Amsterdam]: 1647.

First edition. George Wishart herein sets forth the exploits of the

great Montrose. A copy of this book was hung around Montrose's neck at his execution.

Samuel Rutherford
(1600?–1661)

Rutherford was born in Roxburghshire and educated at the University of Edinburgh where it was noted by the town council that he had "fallen in fornication with Euphemia Hamilton and committed a great scandal in the college." Redemption came with marriage to Miss Hamilton. After studies in theology, Rutherford went on to a successful ministry in Galloway.

Unable to conform to the episcopal powers of the day, Rutherford was forbidden to preach and was confined at Aberdeen until the success of the Covenanters enabled him to return to his parish where he gained influence. He was a commissioner to the Westminster Assembly in London, which set forth the *National Covenant* of 1643, and was principal of St. Mary's College at St. Andrews. Known for his fiery temper, this most perfervid of Presbyterians held doctrinally narrow views but is remembered as an eloquent and devoted minister.

At the Restoration, Rutherford was charged with treason but his final illness cheated the King's summons.

Lex, Rex: the Law and the Prince. . . . London: Printed for John Field, 1644.

First edition. *Lex, Rex* was one of the most influential constitutional statements of the day. Written as an answer to a Royalist book on the divine right of kings, *Lex, Rex* set forth the argument that the people, as represented by Parliament, had the right to depose the King: "These who make the King, and so have power to unmake him in the case of Tyranny, must be above the King in power of Government." Rutherford saw the law as supreme, supplanting the King.

Charles II ordered *Lex, Rex* to be burned at the crosses of St. Andrews and Edinburgh.

Sir Thomas Urquhart of Cromarty
(1611–1660)

One of literature's great eccentrics, Thomas Urquhart was born to a family of ancient stock. He was educated at the University of Aberdeen after which he undertook a grand tour on the Continent.

Urquhart was a staunch Royalist and took up arms for Charles I who knighted him in 1641. After Charles' execution, Urquhart supported the proclamation of Charles II as King. He was taken prisoner at the Battle of Worcester (1651), confined to the Tower and released the next year by Oliver Cromwell. Urquhart is said to have died laughing in 1660 upon hearing the news of the restoration of Charles II.

Urquhart's writing reflected a peculiar genius and delight in extravagant prose. His first major work, written when the author was "surrounded by solicitudinary and luctiferous discouragements" (i.e., debts), was a treatise on trigonometry based on his countryman John Napier's discovery of logarithms. In 1653, Urquhart wrote his version of the stories of Gargantua and Pantagruel by Rabelais now recognized as one of the greatest translations of world literature. Indeed, his Rabelaisian gusto and logorrhea may well have surpassed the original.

εκσκυβαλαυρον: or The Discovery of a most exquisite Jewel. . . . Serving in this place To frontal a Vindication of the honour of Scotland, from that Infamy, whereinto the Rigid Presbyterian party of that Nation, out of their Covetousness and ambition, most dissembledly hath involved it. London: Ja. Cottrel, 1652.

First edition. If Urquhart's version of Rabelais is considered strictly as a translation rather than as an original work, then *The Discovery of a most exquisite Jewel* is the author's most brilliant masterpiece. This mixture of fantasy, nonsense, pedantry, and scholarship is best remembered for Urquhart's mock-heroic account of his hero James Crichton of Cluny, the original "Admirable Crichton."

Sir George Mackenzie of Rosehaugh
(1636–1691)

"Lift the sneck and draw the bar, bluidy Mackingie, come oot if ye daur" sang the foolhardy urchins that ran past Mackenzie's vault in Greyfriar's kirkyard. Mackenzie earned his terrible name by his ruthless prosecution of Covenanters. He boasted that he had never lost a case for the King.

Born in Dundee and educated at the Universities of St. Andrews and Aberdeen, Mackenzie went on to study civil law at Bourges. He began his legal career with a brilliant but unsuccessful defense of the eighth Earl of Argyll. Mackenzie was a man of the highest ability; he wrote widely on political and legal matters, and his essays and fiction are still of interest. An elegant prose stylist, Mackenzie defended the use of Scots.

In 1689, as Dean of the Faculty of Advocates, Mackenzie founded the Advocates Library which later became the National Library of Scotland.

Aretina. Or, The Serious Romance. Part First. Edinburgh: Printed for Robert Broun, 1660.

First edition in four volumes. *Aretina* is the first Scottish novel. It is a pastoral romance set in Egypt and Persia. Under the guise of troubles in the ancient classical world, Mackenzie's book gives a coded history of the Scottish civil wars from James VI through the Restoration.

LENT BY THE NATIONAL LIBRARY OF SCOTLAND, EDINBURGH

John Graham of Claverhouse, First Viscount Dundee
(1649?–1689)

As Montrose had been Charles I's sword in Scotland, so Claverhouse was Charles II's scourge upon the land. Especially severe measures were taken in the west of Scotland by Charles II to compel submission, and it was there that an extreme Covenanting spirit arose. In 1677, Claverhouse began his prolonged effort to subjugate the counties of Ayr, Lanark, Dumfries, and Galloway. This period of harsh repression was known as the "killing time." Sir Walter Scott noted that

among the Covenanters the name of Claverhouse "was held in equal abhorrence and rather more terror than that of the devil himself."

James VII and II created Claverhouse Viscount of Dundee in 1688. Claverhouse failed in his attempt to persuade the King to stay and fight the army of William of Orange and when James fled to France, he placed Claverhouse in charge of military matters.

In 1689, at the Pass of Killiecrankie, the Highland army under Claverhouse defeated William's forces. However, Claverhouse was killed during the battle and his Highlanders were defeated by a Covenanting force soon thereafter.

Letters to the Laird of Clunie, May and July 1689.

These autograph letters to Duncan Macpherson of Clunie were written by Claverhouse as part of his effort to raise the Highland clans in support of James II against the forces of William of Orange.

LENT BY THE LILLY LIBRARY, INDIANA UNIVERSITY, BLOOMINGTON

Andrew Fletcher of Saltoun
(1653–1716)

A lineal descendant of Robert the Bruce on his mother's side, Andrew Fletcher was born in East Lothian. After his father's death in 1665, he was brought up by Gilbert Burnet, later Archbishop of Salisbury; his education under Burnet was followed by the expected gentleman's tour abroad. Fletcher returned to a political life; his opposition to the Stuart kings culminated in his participation in Monmouth's unsuccessful rebellion against James II in 1685 in England. Fletcher escaped punishment, but was condemned as a traitor and his estates forfeited. He was able to return to Scotland following the Glorious Revolution of 1688.

In the last Scottish Parliament (1703), Fletcher stood out as a prominent anti-Unionist. His patriotism and idealism found vehement expression in political pamphlets and speeches. He proposed a federal union, in which England and Scotland could continue to have separate parliaments, and introduced a scheme of "limitations" whereby the power of government in Scotland would be transferred from the Crown to Parliament. He concerned himself with alleviating rural poverty and, in the spirit of the times, he devoted his retirement years to agricultural improvement in East Lothian.

A Defence of the Scots Settlement at Darien with an answer to the Spanish Memorial against it. . . . Edinburgh, 1699.

First edition. Earlier in 1699, the Spanish ambassador, echoed by English politicians, charged that the Scots had no right to colonize in the Isthmus of Panama. Fletcher argues in this pamphlet that the Spanish King's claim to the territory was ungrounded, that Darien was not within Spanish sovereignty, and that England would find it in her interest to support the Scots in their settlement.

The authorship of this pamphlet has also been variously attributed to Archibald Foyer and to George Ridpath.

LENT BY THE LILLY LIBRARY, INDIANA UNIVERSITY, BLOOMINGTON

THE DARIEN SCHEME

In 1695, the Parliament of Scotland passed an act authorizing the establishment of a Company of Scotland Trading to Africa and the Indies. The guiding spirit in this, William Paterson, Scottish financier and founder of the Bank of England, proposed a joint Scottish and English venture but many in England felt that their financial interests were threatened by the formation of the Scottish Company and English public opinion turned against the Scots. There was internal strife between the London and Edinburgh factions of the Scottish Company. By the time the agreed upon sum of £300,000 had been subscribed and the Book closed, the East India Company had petitioned the King for relief, claiming that the Scottish Company represented unfair and possibly illegal competition. The affair went so far as the House of Commons resolving to impeach the Company's directors. Nothing came of the resolution but it marked the end of any hope for a joint venture. William Paterson returned to Scotland to lay the plans for a wholly Scottish venture.

In 1696, with Paterson again as the leading force, the Darien Scheme was brought forward with entirely Scottish capital. It is said that all Scotland subscribed and the £400,000 raised represented nearly all of the national wealth. Under the plan, a Scottish trading colony was to be established on the coast of Darien on the Isthmus of Panama. The Company was to receive a two-percent levy on all exports from the colony, and also reserved for itself one-twentieth of all the lands, gold, silver, jewels, and pearls belonging to the Colony. The first expedition sailed for Darien in July 1698. The problems facing the new settlement were tremendous. In addition to the hostile climate,

the area chosen for the colony had already been claimed by Spain. Moreover, King William of England was anxious not to alienate Spain, and instructed his colonists in America not to aid the Scottish colonists, most of whom succumbed to fever or Spanish attacks. The colony finally surrendered to the Spaniards in 1700; the venture had cost 2,000 lives and most of the Company's capital.

The failure of the Darien Scheme was a tremendous blow to Scotland both economically and psychologically. Most Scots blamed King William and his English advisors. It was apparent to many that Scotland's future prosperity depended on a political as well as a monarchical union in which cooperation would replace the conflicting advice of the two Parliaments.

Act For a Company Tradeing to Affrica and the Indies, June 26, 1695. Edinburgh: Printed by the Heirs and Successors of Andrew Anderson, 1695.

LENT BY THE JOHN CARTER BROWN LIBRARY AT BROWN UNIVERSITY

The Subscription Book of the Company Trading to Africa and the Indies, Established under the Act passed by the Scottish Parliament in June 1695.

The subscription book for the joint English-Scottish venture which came to naught. Heading the list is the name of William Paterson (1658–1719), the Scottish financier. Other major subscribers and directors included Thomas Coutts and Joseph Cohen D'Azevedo. The document gives the regulations of the Company, followed by the name of the subscribers and the amounts of their subscriptions.

LENT BY THE LILLY LIBRARY, INDIANA UNIVERSITY, BLOOMINGTON

Company of Scotland Trading to Africa and the Indies. A Perfect List of the several Persons Residenters in Scotland, Who have Subscribed as Adventurers In the Joynt-Stock of The Company of Scotland Trading to Africa and the Indies. Together With the respective Sums which they have severally Subscribed in the Books of the said company, Amounting in the Whole to the Sum of 400,000 lb. Sterling. Edinburgh: Printed and Sold by the Heirs and Successors of Andrew Anderson, 1696.

The later subscription book for the entirely Scottish and ill-fated venture in the New World that bankrupted the country.

Charles Leslie
(1650–1722)

Gallienus Redivivus, or Murther will out &c. Being a true Account of the De-Witting of Glencoe, Gaffney, &c. Edinburgh, 1695.

First edition. This pamphlet, printed after the Scottish Parliament had decreed the killings at Glencoe were murder, forced the government to set up the first royal commission "to apportion blame in the matter." Many in England denied the massacre, calling the reports false and the event "a Jacobite story."

When the Highland forces had been defeated in 1689, an indemnity was eventually offered by the Crown to those who would take the oath of allegiance to King William before 1 January 1692. MacDonald of Glencoe was willing but unable to take the oath in time and it was decided by the King, or by his advisors in Scotland, to teach the clan a lesson. In February 1692, a detachment of troops led by Campbell of Glenlyon was quartered in the houses of the MacDonalds where they were offered hospitality by the chief and his people. The soldiers' orders were to wipe out the entire clan. Escape was difficult as the author of this pamphlet vividly describes: "And how dismal may you imagine the Case of the poor Women and Children was then! It was lamentable, past expression; their Husbands and Fathers, and nearest Relations were forced to flee for their Lives; they themselves almost stript, and nothing left them, and their Houses being burnt, and not one House nearer than six Miles; and to get thither they were to pass over Mountains, and Wreaths of Snow, in a vehement Storm, wherein the greatest part of them perished through Hunger and Cold. It fills me with horror to think of poor stript Children, and Women, some with Child, and some giving Suck, wrestling against a Storm in Mountains, and heaps of Snow, and at length to be overcome, and give over, and fall down, and die miserably."

Reading this, one can pick up the speech pattern, the cadence of repetition and phrasing that is Highland.

Martin Martin

(d. 1719)

Martin was born on Skye. He was factor to the Laird of Macleod and at the request of Sir Robert Sibbald, the scientist and antiquarian, Martin travelled the Western Isles collecting information. His is the only detailed account of the Hebrides before the '45 Rising and Culloden opened the Highlands to change.

Martin described the Western Isles as a charmed world where the people got by with prayers, incantations, and charms. It was a land of desperate hardship whose people were described by one scholar as "scant, starveling . . . ferociously combative . . . clinging to their bleak hillsides and wedded to their backward customs. . . ." Austerity was the norm for rich and poor alike; the castles of the chieftains provided security and grandeur without luxury.

Martin understood the values that underlay the barbarous life and the extent to which clan attachments compensated for poverty. "Though poor, I am noble," was a saying among the Macleans, "Thank God I am a Maclean." It was the archaic, near-mystical core of the chief that made the clan system work. Leaders in battle and fathers to their people, they were virtually independent sovereigns. It is not surprising that neither the king's peace nor the law of the land was heeded in those parts.

A Description of the Western Islands of Scotland. London: Printed for Andrew Bell, 1703.

First edition. Martin first contributed this work as a short paper to the Royal Society's *Philosophical Proceedings* in 1697. Elaborated upon, it was published with a map in 1703.

One of the most celebrated books on the Western Isles, it was presented to Samuel Johnson by his father and was responsible for Johnson's famous tour of the Hebrides with the Scotsman James Boswell in 1773.

LENT BY THE LILLY LIBRARY, INDIANA UNIVERSITY, BLOOMINGTON

THE EIGHTEENTH CENTURY

THE UNION OF THE PARLIAMENTS

THE catastrophic results of Scotland's colonial enterprise, the Darien Scheme, led to a great debate on the Union of the Parliaments of Scotland and England. The nobles and most members of the Scottish Parliament were in favor of the Union while the Scottish people stood against it. There was much pamphleteering; some anti-Union writers suggested that the pro-Union faction in Parliament had been bribed.

In 1707, under the reign of Queen Anne, the Act of Union was passed. Under the terms of the treaty, Scotland retained her own Church as well as her own legal, justiciary, and banking systems. A complicated financial system of "equivalents" was also created, mainly to compensate Scotland for her involvement in the national debt. In effect, Scotland gave up her self-government when the Scottish and English Parliaments became the Parliament of Great Britain.

SCOTTISH GAELIC LITERATURE

Until the 16th century, Scotland and Ireland were politically, socially, and linguistically one. "There was a community of interest in the common heritage and a free intercourse of harpists, bards, storytellers and scholars who crossed and recrossed the water and it is safe to say that in no part of Britain was there such a mass of ancient literature and a keener cultivation of it" (Maclean). The end of the 15th century brought change; the Lordship of the Isles, the great bond between Ireland and Scotland, was broken up and increasingly the Scots advanced their own dialect to the position of a literary language. Women numbered significantly among the bards. The 19th-century Gaelic scholar, the Reverend Dr. Donald Maclean, tells us that Mary Macleod (Màiri nighean Alasdair Ruaidh, 1615?–1705) was the preeminent bard of her time. She was the family bard of the clan chief Macleod of Dunvegan. She brought a new simplicity to the intricate and difficult meters of the old Gaelic poetry, and her poems rank as the most precise, elegant, and "sweetest" of her generation. Illiterate poets such as Mary Macleod (the tradition was an oral one; most poets could neither read nor write) are perhaps the most interesting as they were the most faithful to human nature. Also of interest in Gaelic literature are the descriptions of the female. "Woman had

slowly come into her own under the external influence of civil and re-
ligious law" (Maclean). The love poetry of the Gael expresses the pur-
suit of the eternal illusion of the ideal woman, but also contains bitter,
satiric material featuring "woman flawed."

The Gaelic tongue bound together a band of emigrants scattered to
the far-flung regions of the globe. Dr. Maclean remembered that "an
old lady in the subtropics of Australia rehearsed in my hearing verse
after verse of 18th-century Gaelic poetry, transporting herself in the
very act to the days of childhood, 'round the peat fire in far away
Lochaber. From lip to lip the songs have wafted from one generation
to another. Their intensity of feeling has fired the spirit of many a for-
lorn Gael. The future historian who will portray Highland life or
character in its vicissitudes and its joy will fail to do so accurately un-
less he studies diligently the literature of the Scottish Gael." Now
nearly extinct as a living language, there is a revival of interest in this
language and culture.

The Fernaig Manuscript (MS Gen. 85)

This unique manuscript is very important as a collection of early
Gaelic poetry. It was compiled, and in part composed, by Duncan
MacRae of Inverinate in Ross-shire between 1688 and 1693.

Most of the poets are 17th-century North Country gentlemen. The
contents are mostly religious (Episcopal) and political (Jacobite). The
manuscript supports the Stuarts, decries the Hanoverian regime, and
contains doleful songs on the dynastic revolution of 1688. The domi-
nant theme is a very Celtic one: disillusionment with the changes and
vanities of the world coupled with religious aspiration. Love songs
and drinking songs are conspicuously absent. Ossianic literature is
represented with only 36 lines out of the manuscript's 4,200. There are
57 poems. The ancient Celtic views of the afterlife are also included:
Hell is a place of exposure and cold while Heaven (*tir nan og*) is a
green and sunny isle set in the Western Ocean.

The poem displayed from volume 1 is one of MacRae's own com-
positions in which the poet employs the well-known medieval device
of a dialogue between the Body (*A'Cholainn*) and the Soul (*Ant-
Anam*). The Soul warns the Body against the sinful misuse of the
Lord's Day, urges church attendance and the avoidance of alcoholic
roistering afterwards.

The fact that university-educated MacRae chose to write the po-
ems in a Scots-based orthography of his own devising, rather than in

the traditional Gaelic manner, means that some features of his local Gaelic dialect come to the fore, giving the manuscript an added scholarly interest.

LENT BY THE GLASGOW UNIVERSITY LIBRARY

Alexander Macdonald
[Alasdair MacMhaister Alasdair] (1700–1780)

An Argyllshire man, Macdonald was the son of the Episcopal clergyman of Ardnamurchan. His father intended him for holy orders; Alan Macdonald, his clan chief, 12th chief of Clanranald, intended him for the law. With the assistance of the latter, Alexander attended Glasgow University. Upon returning to his native parish, he worked as a schoolmaster and associated himself with the Presbyterian Church.

In 1741, Alexander Macdonald wrote a Gaelic-English dictionary, the first of its kind.

Repenting of his Presbyterian connections, Macdonald became a Roman Catholic and joined the Jacobites in support of Bonnie Prince Charlie. Holding a commission in the Highland army, he wrote impassioned verse addressed to the clans. After Culloden, Macdonald wandered from one hiding place to another until the Act of Indemnity provided the opportunity to settle. Clanranald appointed him Baillie of the Island of Canna and gave him a farm where he composed most of his poems.

Foremost among the secular poets, Macdonald shows a duality of ferocity and tenderness in his poems, which creates the striking contrasts in his poetry. His powerful description of Clanranald's war galley in action in the brilliant *Birlinn Chlann-Raghnaill* has earned the poem a privileged place among the masterpieces of Gaelic poetry.

Ais-Eiridh na sean Chánain, Álbannaich. Clo-bhuailt' ann Duneidiunn, go feim an Ughdair, 1751.

First edition. Such was the supposed potential for treason that all known copies of this book were burned by the hangman in Edinburgh. Surviving copies are rare.

The title means *Resurrection of the Ancient Scottish Tongue* and the contents, for the most part, are ardent poems in support of the Stuart cause; they also express concern for the interests of the Gaelic-speaking peoples. Love songs are represented, including the poet's fa-

mous *Morag*, written in *pibroch* measure (i.e., in the formal cadences of the great classical music of the Highland bagpipes).

Macdonald's poems influenced Duncan Ban MacIntyre.

Duncan Ban MacIntyre
[Donnchadh Bàn Mac An T-Saoir] (1724–1812)

Duncan Ban MacIntyre was born in Glen Orchy in Argyllshire. He was a game-keeper and forester and this close contact with nature was a major influence on his writing. Another influence was the work of his fellow Gael, Alexander Macdonald, whose verses were read to him by the local minister as Duncan was illiterate. When Duncan began to compose his own poems, the minister's son wrote them down, editing and preparing them for press. It is said that Duncan could recite all his poems, amounting to some 7,000 verses. Three editions of his work were published in his lifetime and he was able to live off his writings.

Under pressure of his clan chief, John Campbell, second Earl of Breadalbane, Duncan joined the forces of the Hanoverian government. Among his songs in praise of the Campbells, his *Lament for Colin of Glenure* celebrated the sensational Appin murder (so wonderfully written of by Robert Louis Stevenson in *Kidnapped*). MacIntyre ended his days in Edinburgh as a member of the City Guard.

Orain Ghaidhealach. Clodh-bhuailt ann Dun-Eidin le A. MacDhonuil air son an Ughdair, 1768.

First edition. As Macdonald's descriptions of battles are second to none, so Duncan Ban MacIntyre's poems in praise of natural beauties stand alone. His great feeling for nature and his delight in its beauty are expressed in vivid descriptions of Highland scenery in which no detail is too small for eloquent consideration. Animals feature prominently as do various aspects of the inanimate.

Included here are two of the poet's greatest poems, *Orain Coire a Cheathaich* (*Song of the Misty Corrie*) and *Moladh Beinn Dobhrainn* (*In Praise of Ben Doran*). In *Moladh*, "the unsophisticated child of nature caresses the Ben with all the affection of real filial attachment. He smooths her wrinkles and decks her with resplendent glory" (Maclean). These poems reflect the idealism as well as that close affinity between

man and nature that characterized the early Celtic experience.

The intricate rhyming structure of the poetry derives from the customary changes in slow and quick time of *pibroch* rhythm.

LENT BY THE GLASGOW UNIVERSITY LIBRARY

THE JACOBITE UPRISINGS: 1715–1746

The accession of James VII of Scotland and II of England heralded a long period of religious and political turmoil for both kingdoms. An ardent Catholic, he was determined that his co-religionists should play their part in government but the majority of his nobles, landed gentry, and the clergy in both kingdoms were strongly opposed. In 1688, Protestant William of Orange and his wife Mary entered England at the invitation of Parliament. Shortly thereafter James took refuge in France; in later years, he and his family lived in Rome under the protection of the Pope.

During all this time there was unrest in Scotland and the massacre of Glencoe shamed even London. The Scots Parliament tried to continue to run on its own but with the failure of the Darien settlement in Central America, it faced poverty if not ruin. After the death of Queen Anne in 1714, a distant but Protestant Stuart from Hanover was crowned George I. The Jacobites led by the Earl of Mar saw their chance and in 1715 James Francis Edward Stuart, the "Old Pretender," landed. His coronation took place at Scone where he was named James VIII of Scotland and III of England but after an inconclusive battle at Sheriffmuir he returned to France and his rising collapsed. The Stuart cause continued to smoulder and in 1745 Bonnie Prince Charlie, the son of the "Old Pretender," landed in the North. Many of the clans rallied to him; and against all odds he occupied Edinburgh and won a great victory at Prestonpans. Rashly, he advanced into England with 5,000 ill-equipped forces—the English fleet having blocked French supplies of men, money, and weapons. They reached Derby, only 100 miles from an alarmed London, but against the wishes of the Prince his commanders decided to withdraw to Scotland. The English army under the ruthless Duke of Cumberland pursued them. Some months later, in April 1746 at the Battle of Culloden, the Prince was totally defeated. "Butcher" Cumberland allowed no quarter, wasted the Highlands, and destroyed the clan system. Many who failed to escape were summarily put to death. The journeyings of the Prince are the stuff of legend: a huge reward was put on

his head and he furtively slipped from isle to isle until finally reaching France. The last of the Stuart line was Henry Cardinal York who died in 1807.

During the Jacobite era, there was little Scottish literature; writing in the main was confined to pamphleteering for or against the Union and the Jacobite king.

James Francis Edward Stuart
(1688–1766)

James Francis Edward was born in London, the son of James VII and II and his wife Mary of Modena. Before his father's death in exile at the court of St. Germain in 1701, the English Act of Settlement had excluded the male line of Stuarts from the succession. Thus, young James was attainted in 1702. His restoration became the object of numerous plots and wars by the Jacobites between 1708 and 1745. When James Francis Edward died, he had represented the Stuart claim to the British throne for nearly 64 years–longer than any crowned monarch had held it.

Sebastiano Paoli. *Solenni esequie di Maria Clementia Sobieski. . . .* Fano: [1736].

A copy of the description of the obsequies of Maria Clementina Sobieski (d. 1735), the daughter of the ruling family of Poland, and wife of James Francis Edward Stuart, who was claimant to the throne of Scotland as James VIII and of England as James III (1688–1766).

The red morocco binding profusely gilt bears the royal arms of James Francis Edward; it is ascribed to Iacopo Bona, a preeminent 18th-century Roman binder.

PRIVATE COLLECTION

Charles Edward Stuart
(1720–1786)

Born in 1720 at his father's Palazzo Muti in Rome, he was the son of James VIII and III and Maria Clementina Sobieski.

A medal with the motto *Spes Britanniae* was struck to commemo-

rate the young prince's birth. He did indeed grow up as the Jacobite's hope, but all hope was smashed in the final defeat at Culloden. Charles fled back to France after hiding out in the Highlands and Western Isles; guarded by loyal clansmen he eluded his pursuers.

The remainder of his life was a long, sad dénouement marked by debauchery. He lived for some years with a loyal Scotswoman, Clementina Walkinshaw, with whom he had a daughter who became the chief comfort of his last years. Near the end of his life, he made a wretched marriage with the much younger Princess Louise of Stolberg-Gedern. He died in Rome. The inscription on his tomb reads "Charles III, King of Great Britain."

Letter to James Drummond, Duke of Perth. Paris, 16 May 1745.

An autograph letter signed by Prince Charles optimistically ordering the Duke to "surprise and seize the Castle of Stirling for His Majesty's use and service and to secure and defend the same until you receive further orders from us."

One of Charles Edward's foremost Scottish supporters and a Lieutenant-General of his army was James Drummond, Earl and titular Duke of Perth, whose father had supported James VIII in 1715. Not even he, however, could take the strongly fortified castle which was being used as a headquarters by General Sir John Cope, the government's Commander-in-Chief in the "North of Britain."

This letter is important for it indicates Charles Edward's determination to land in Scotland during the summer of 1745 and proceed to England without French help.

PRIVATE COLLECTION

A Short Narrative of the Battle of Falkirk. . . . 17 January 1746.

The Battle of Falkirk, adjacent to the field where the Battle of Bannockburn occurred, was the last great victory for Prince Charles Edward and his army. This broadside shows the dispatch of an observer at the battlefield. It has been thought that Prince Charles' army included a portable printing press and that this sheet was actually produced on the site of battle.

PRIVATE COLLECTION

Henry Stuart, Cardinal York
(1725–1807)

Letter to the Duke of Melfort. Rome, 7 February 1737.

Autograph letter signed. In this delightful missive from the young Henry, one can almost hear the boy's tutor saying, "Be a good boy and sign your response."

The younger son of James VIII and Maria Clementina Sobieski, Henry attained great success and wealth in the Church. Known as Cardinal York, Henry held court at Frascati. When Boswell toured Italy in 1765, he visited the aged and failing James VIII in Rome, going on to see Henry celebrate mass. Boswell exclaimed afterwards that the cardinal was "most majestic and elegant" with the face of an angel.

Henry survived his brother, Charles Edward, by nearly 20 years, preserving the outward symbols of monarchy but never pressing its political claims. He chose the title "Henry IX, King of Great Britain, France and Ireland, Defender of the Faith."

PRIVATE COLLECTION

THE ENLIGHTENMENT

When Robert Burns visited Edinburgh in 1787, he entered into, to use Smollett's phrase, "a hot bed of genius." The remarkable gathering of intellectual lights that crowded into this narrow niche of time and place justified Edinburgh's title, the "Athens of the North."

To quote from the essay, "Eighteenth Century Scotland," by Alexander Gray: "In entering an exhibition of Scottish books of the eighteenth century, the visitor will do well to turn over in his mind the miracle of eighteenth-century Scotland in the world of thought, and in all that is concerned with literature, philosophy and science. . . . There was no intellectual questioning in Scotland on the morrow of the Union of 1707. The eighteenth century presents us with a transformation so sudden and so complete that it is difficult to think of a parallel. From being neglected and negligible, Scotland, by the end of the eighteenth century, had come near to assuming, if she had not actually assumed, the intellectual leadership of Europe. . . . And so let the silent books speak. They will tell of a century which is also in large measure a

continued warfare against inherited gloom and rigidity, carried on, within the Church and without, by a newer spirit of tolerance in all things. . . . They will tell of a century when there were some in Scotland anxious to speak with propriety and to bury the past in the new found glory of becoming North Britain, while there were others more determined than ever to remain Caledonia, stern and very wild. But more especially the books will speak of what is peculiarly within their province, of a century during which Scotland, from being poor in spirit, moved mysteriously to her finest hour."

Tobias Smollett
(1721–1771)

Born into an old and prominent family in Dumbartonshire, Smollett was educated at Glasgow University where he studied medicine, later obtaining a medical degree at Marischal College, Aberdeen. Smollett determined to seek his fortune in London where he took kindly to tavern life and coffeehouse society; he was considered a great acquisition to the Scottish circle there. Smollett struggled for a number of years to combine the careers of medicine and literature; but recurring financial hardships and, above all, a choleric and irritable nature discouraged his practice of medicine and he turned entirely to writing. Smollett's novels, his great history of England, his lays, political writings, and journalism were successful though he seems always to have lived beyond his means. Moreover, Smollett could be nasty and as a result incurred many ill-feelings. As a director of *The Critical Review*, he was imprisoned for three months for a libelous article.

Early in his career, Smollett had signed on as a ship's surgeon on a voyage to the West Indies. There he met the daughter of an English planter–a Creole lady whom he married. Smollett was a devoted husband and father to his wife and daughter, on whom he doted. Rarely did they see the dour visage with which he confronted the world. His daughter's death in 1763, at the age of 15, was a blow from which Smollett never wholly recovered.

Worn down by personal tragedy and his prolific output, Smollett sought relief in travel abroad. He spent a summer in Edinburgh, whose society–then at the apogee of its brilliance–paid him due attention. He received visits from Hume, Home, Robertson, Adam Smith, Blair, Alexander "Jupiter" Carlyle, and others.

In deteriorating health, Smollett spent the last two years of his life in a small town in northern Italy in the constant company of his wife.

Tobias Smollett, M.D.

Unknown Artist
Stipple Engraving
21.9 x 13.7 cm. (8⅝ x 5⅜ in.)

The Tears of Scotland. [Edinburgh? 1746/50?].

It was courageous of Smollett to publish this sincere expression of his
sorrow at the hardships imposed on Scotland by England when the
Jacobite uprising was suppressed. His friends advised against publica-
tion, but the pamphlet appeared, albeit anonymously, some time be-
tween 1746 and 1750.

PRIVATE COLLECTION

*The Expedition of Humphrey Clinker. By the Author of Rod-
erick Random.* London: Printed for W. Johnston and B.
Collins, 1671 [1771].

First edition. Smollett's last and best novel, among the greatest of the
18th century, and a masterpiece of the English epistolary novel. Al-
though Smollett wrote in standard English, scholarly opinion argues
that he did so as a Scot. The point of view in his novels is generally
that of an outsider: Squire Bramble, a Welshman, expresses a particu-
lar affinity with the author's own part of Scotland, the Lennox and
Strathclyde, and affords many glimpses of Scottish social life (Mac-
Queen). In his book *The Protean Scot*, Professor Kenneth Simpson
sees Smollett as writing within the older Scottish literary tradition,
whose caricatures are a major legacy, with Scott and Galt the most im-
mediate beneficiaries.

Smollett wrote *Humphrey Clinker* during his final illness and only
just received it from the press before he died.

PRIVATE COLLECTION

Francis Hutcheson
(1694–1746)

Hutcheson was the son of a Presbyterian minister living in northern
Ireland; his grandfather had emigrated from Ayrshire where the fam-
ily was considered "ancient and respectable."

He was educated at Glasgow University and was elected to its Chair of Moral Philosophy which he filled with extraordinary distinction. Hutcheson was an excellent lecturer; though quick-tempered, he was remarkable for his cheerfulness and unaffected benevolence, helping poor students by lending them money and admitting them without fees to his lectures.

Hutcheson's ethical writings are his most important. His first essays were directed against the selfish, cynical theories of Hobbes. According to Hutcheson's theory of virtue, there is in man a "moral sense" which approves the quality of benevolence in any act. He taught that by morality man can serve a benevolent God. His theology revolutionized religious thought by strongly influencing the liberalizing, evangelical wing of the Scottish Church. Hutcheson also did much to promote a psychological study of the moral faculties. "Whoever came in contact with Hutcheson testified to the remarkable influence which he wielded. Adam Smith was one of his devoted pupils; Hume consulted him on moral and ethical problems. . . . Indeed it is not too much to call Hutcheson the real founder of the liberal movement that had grown to such alarming proportions by the time Burns wrote his satires" (Snyder, *Life of Burns*).

An Inquiry into the Original of Our Ideas of Beauty and Virtue. London: Printed by John Darby for William and John Smith in Dublin; and Sold by William and John Inys, John Osborn, and Samuel Chandler, 1725.

First edition. Hutcheson's philosophy set forth here, and later elaborated on in his *System of Moral Philosophy* (1755), had a far-reaching influence on the "Common-Sense" School. The author became the first exponent of Utilitarianism, stating "that Action is best, which accomplishes the greatest Happiness for the greatest Numbers."

PRIVATE COLLECTION

Allan Ramsay
(1684–1758)

Born in Lanarkshire, Ramsay was educated at the parish school until his 15th year, at which time he was apprenticed to an Edinburgh wigmaker. He and his friends enjoyed his gift for rhyming and his membership in the Jacobite Easy Club (founded in 1712) where he was

laureate. Ramsay abandoned wigmaking for bookselling and opened a successful shop at the Luckenbooths, opposite St. Giles. There, in 1725, he established the first circulating library in all of Britain. His interests also extended to the theatre; he opened a playhouse which was closed down within a year because of church-based disapproval and because the Licensing Act of 1737 banned theatrical performances in Britain except in the city of Westminster, and then only when the monarch was in residence. A burgess of the city, Ramsay was a popular figure with the gentry and aristocracy. His son, Allan, was the illustrious portrait painter.

Other than occasional poems issued in sheets at a penny a copy, Ramsay first published, in 1716, *Christis Kirk on the Green*, a burlesque poem in Scots that has been attributed both to James I and James V. Characteristic of his creative approach to editing, Ramsay added a second canto of his own.

Ramsay stressed the importance of using Scots in his own poems, and his commitment to the Scottish literary heritage was evident in his two major anthologies of early Scottish verse, *The Ever Green* (1724) and *The Tea Table Miscellany* (1723). The latter was especially popular and subsequent volumes appeared. Although Ramsay's editorial standards have been deplored, he did succeed in gaining a wider audience for early Scots poetry. He is at his best in his richly comic poems, the mock elegies of his Edinburgh friends, and his verse epistles.

"Although Ramsay did not actually found the 18th-century revival in Scottish literature, that honour belongs to James Watson with his *Choice Collection*, Ramsay added to it and popularised it in such a manner as to ensure its success. If Burns drew more from Fergusson in his satires and epistles, where song work was concerned, Ramsay was his model" (Lindsay).

The Tea Table Miscellany. Edinburgh: Printed by Mr. Thomas Ruddiman for Allan Ramsay at the Mercury, opposite to the Cross-Well, 1723.

Ramsay brought out four volumes of this bestseller between 1723 and 1737. This is the only known copy of the first edition of the first volume; it is printed in a different type setting from that of the 1724 edition.

A mixture of traditional songs and ballads frequently altered by Ramsay to suit the taste of his own day, this collection also includes contributions by contemporary poets and by Ramsay himself.

An interesting contemporary included here is Lady Grizel Baillie (née Home, 1665–1746), a Covenanter heroine who wrote in prose and verse. One of her songs, *And were 'na my heart light I wad dee*, has passed imperishably into the Scottish song literature. "Its sudden inspiration," says Tytler, the great 18th-century enthusiast of Scottish song, "has fused and cast into one perfect line the protest of thousands of stricken hearts in every generation."

LENT BY THE BEINECKE LIBRARY, YALE UNIVERSITY

The Gentle Shepherd, a Pastoral Comedy. Glasgow: Printed by A. Foulis, and Sold by D. Allan . . . Edinburgh, also by J. Murray . . . and C. Elliot . . . London, 1788.

First published in 1725, this is the first illustrated edition of the esteemed Foulis Press, with 12 aquatints by David Allan and 18 pages of engraved music to accompany the songs.

This pastoral romance, or operetta, is regarded by many to be Ramsay's best work. It was an immediate success, though it reads better than it plays.

David Allan's already distinguished name became a household word with his illustrations for this work. Robert Burns expressed his admiration in a letter of 1794: "By the bye, do you know Allan? He must be a man of very great genius. Why is he not more known? Has he no Patrons; or do Poverty's cold wind and crushing rain beat keen and heavy on him? I once, and but once, got a glance of that noble edition of the noblest Pastoral in the world, and dear as it was; I mean dear as to my pocket, I would have bought it; but I was told that it was printed and engraved for subscribers only."

Note the two ballads tacked on the cupboard door in the illustration (not shown in catalogue).

PRIVATE COLLECTION

James Watson
(d. 1722)

James Watson was born in Aberdeen, the son of a merchant who turned to printing. James set up his own printing shop in Edinburgh in 1695. He was imprisoned in the Tolbooth in 1700 for printing a pamphlet entitled *Edinburgh's Grievance Regarding Darien* but was re-

leased when a mob forced entrance to the prison by burning and battering down the doors.

"In beauty and accuracy of workmanship, Watson quite surpassed his Edinburgh contemporaries" (DNB). Among the outstanding products of his press were periodicals and several major works, chief of which was his Bible of 1722. His most memorable, however, was *A Choice Collection of Comic and Serious Scots Poems Both Ancient and Modern*.

A Choice Collection of Comic and Serious Scots Poems Both Ancient and Modern. Part I, by Several Hands. Edinburgh: Printed by James Watson, 1706.

First edition. Watson is best remembered for this book which is the first published anthology of Scots vernacular verse. His compilation and publication of it testifies to the revival of interest in Scots culture at the time, in reaction to growing English political ascendancy and to the 1707 Act of Union. *A Choice Collection* was issued in three volumes between 1706 and 1711.

The collection contains a curious assortment of verse ranging from the famous early poems, *Christis Kirk on the Green* and Montgomerie's *The Cherry and the Slae*, to contemporary broadsides of limited merit. Unlike later compilers of anthologies, Watson, a printer by trade, relied exclusively on printed sources. As much important Scottish verse survived only in manuscript form, this limited the range and quality of the material at his disposal. However, *A Choice Collection* is the foundation of the revival of Scots verse, and along with Ramsay's *Ever Green* anthology, is the main source of Burns' acquaintance with the old Scottish poets.

This copy of the anthology belonged to the English antiquary Joseph Ritson and contains extensive manuscript notes in his hand.

LENT BY THE G. ROSS ROY COLLECTION, THE THOMAS COOPER LIBRARY, UNIVERSITY OF SOUTH CAROLINA

The History of the Art of Printing, containing an account [sic] invention and progress in Europe: with the names of the famous printers, the places of their birth and the works printed by them. And a preface by the publisher to the printers in Scotland. Edinburgh: Printed by James Watson; sold at his shop; David Scot; George Stewart, 1713.

First edition. This rare and extraordinary book is divided into three parts. The first part is an interesting history of Scottish printing from its beginnings to Watson's own day, and much valuable information is preserved here. The second part is a fine 48-page catalogue of type specimens of Watson's own establishment and is the earliest such catalogue. The third part is a survey of 15th-century printing and is the most conventional part of the book, being adapted from a French source.

Very much in the spirit of the Enlightenment, Watson had as his goal the improvement of the craftsmanship of the art of printing in Scotland which at the time, because of greed and technical incapacity, had fallen into discredit.

PRIVATE COLLECTION

James Thomson
(1700–1748)

James Thomson is the greatest and most accomplished Scottish writer of English verse during the 18th century. He was born in a small village in Roxboroughshire where his father was a minister; his mother was related to the third Earl of Home. Thomson studied for the ministry at the University of Edinburgh but criticism of his prose style determined him to devote his energies to poetry. He set sail for London in 1725 where he looked to his mother's prominent relations for aid: a distant and supportive kinswoman was the poetess, Lady Grizel Baillie of Jerviswoode. Through his literary work, Thomson gained such important patrons as George, first Lord Lyttelton, and Frederick, Prince of Wales.

His two major works, *The Seasons* and *The Castle of Indolence*, exerted a considerable influence on English literature. Thomson was the first to challenge the ideal of artificiality, which had held sway under Pope, and to transmit the unaffected sentiment inspired by nature.

Rule Brittania is another well-known poem by Thomson. It first appeared in 1740 in *The Masque of Alfred* composed by Thomas Arne. Thomson himself also wrote many plays which enjoyed a measure of contemporary success.

Thomson died at his home in Kew mourned by his numerous friends. Lyttelton wrote: "Not one immoral, one corrupted thought, one line, which dying, he could wish to blot."

Spring. London: Printed and sold by A. Millar . . . and G. Strahan, 1728.

First edition. Preceded by *Winter* and *Summer* in 1727, *Spring* further enhanced the author's fame and increased his prosperity. The poem's dedication celebrates his patroness Frances Seymour, Countess of Hertford. The last page sets forth the author's proposal to print *The Four Seasons* by subscription which the author and his publishers would collect at the Smyrna Coffeehouse in Pall Mall.

PRIVATE COLLECTION

The Seasons. London, 1730.

First collected edition. This handsome volume contains the first printing of the poem *Autumn* and includes, at the end, *A Poem Sacred to the Memory of Sir Isaac Newton*, inscribed to Sir Robert Walpole. The illustrious list of subscribers includes both Walpoles (Horace and Robert), Allan Ramsay, and Alexander Pope (who ordered three copies). There are five copper-plate engravings after the famous landscape gardener and painter, William Kent, to illustrate the seasons.

Thomson observed nature with such feeling and suggested its moods so powerfully that *The Seasons* were to strike a note in English literature that would be recaptured and developed by Wordsworth and the Romantic movement in the next century. Robert Burns wrote in his 19th year: "My reading was enlarged with the very important addition of Thomson's work." Indeed, *The Seasons* enjoyed enormous popularity over the next 100 years throughout Britain, France, and Germany.

PRIVATE COLLECTION

Henry Home, Lord Kames
(1696–1782)

Born to a gentleman of small fortune at Kames in Berwickshire, Home trained for the law at Edinburgh before being raised to the bench as a Lord of Session. His title is taken from his birthplace. Distinguished in his legal practice and writings, he rose to be Senator of the College of Justice and Lord Commissioner of Justiciary. Lord Kames was one of the last of the old school of Scottish judges to use Scots inside and outside the courts.

He was a leading member of the literati and combined his knowledge of the law with "a great taste for metaphysics." He wrote *Essays on the Principles of Morality and Natural Religion* (1751) in opposition to the teachings of David Hume and with the purpose of vindicating religious faith. But the times were not right and his gambit proved unsuccessful. In particular, a violent controversy, set off by an anonymous pamphlet, caused the General Assembly of the Church to issue a warning against "pernicious infidels" and to classify Kames as such along with Hume. A charge of heresy was brought against Kames but was soon dismissed. Kames fared better with his *Elements of Criticism* (1762).

Lord Kames acquired a considerable reputation as a gentleman farmer based not only on his writings on the improvement of agriculture but also on his enlightened management of his estate at Blair Drummond where he introduced modern methods of cultivation and land reclamation.

Elements of Criticism. Edinburgh: A. Millar, J. Kincaid and J. Bell, 1762.

First edition published in three volumes. *Elements of Criticism* made the author's name as a critic and a man of letters and spread his fame far and wide, but Voltaire ridiculed him—probably because Lord Kames had condemned his *Henriade*.

Lord Kames here analyzes beauty, taste, composition, and art, averring that all judgment on art and letters rests on fixed principles. Feeling—not reason—is the infallible judge of taste and beauty.

LENT BY THE LILLY LIBRARY, INDIANA UNIVERSITY, BLOOMINGTON

David Hume

(1711–1776)

David Hume was born in Edinburgh to a family whose ancestral home was Ninewells in Berwickshire. Hume graduated from the University of Edinburgh and then set off for La Flèche in Anjou where he wrote his *Treatise of Human Nature*. Returning to Scotland, he continued to write and made important contributions in the areas of philosophy, politics, economics, and theology. A member of the Select

Society, he was a central figure in the extraordinary social life of Edinburgh. He sought his friend Adam Smith's place in the Chair of Logic at Edinburgh University but was disappointed. He was, however, made Keeper of the Library of the Faculty of Advocates in 1752. Although attacked for his free thinking, Hume was, as he says, "supported by the ladies."

Though the skepticism of his writings brought down the wrath of the churchmen, and his philosophy was diametrically opposed to that held by many of the literati, he coexisted pleasantly with his contemporaries and enjoyed many notable friends. Among his diplomatic appointments was a three-year stay in France as Secretary to the Ambassador and Chargé d'Affaires. His intellectual achievements and his good nature ensured a rapturous appreciation of his presence in French society. He enjoyed the friendship of D'Alembert and Turgot, and as close a relationship with Rousseau as the latter's unstable temperament would permit.

Important writings were *Philosophical Essays Concerning Human Behaviour, An Enquiry Concerning the Principles of Morals, Political Discourses,* and *Four Dissertations,* which included the suppressed essays "Suicide" and "The Immortality of the Soul." As a philosopher, Hume extended the empiricism of Locke, evolving a new theory which stressed that human knowledge is man-made and that our understanding of the facts of the universe is founded on the workings both of human nature and of the imagination and that therefore natural beliefs cannot be based on rationalism. Hume's speculative writings were completed by 1751 at which time he turned to his well-received *History of England from the Invasion of Julius Caesar to the Revolution of 1688.* Completed in 1763, this history remained a standard text for many years. He lived with his sister in Jack's Land in Edinburgh's Canongate (*Land* meaning one of the city's lofty compound houses), and, in his later years, in a house in the New Town. His writings had gained him great wealth which was augmented by a pension from the King.

Hume never expected his skepticism to influence the practice of either political or ecclesiastical matters. Not one to proselytize, Hume advised a young skeptic to take Anglican orders because "it was paying too great a respect for the vulgar to pique oneself on sincerity with regard to them," and expressed the wish that he himself could still be a hypocrite.

David Hume

Joseph Collyer (1748–1827) after an unknown artist
Engraving
18.1 x 11.4 cm. (7⅛ x 4½ in.)

LENT BY THE YALE CENTER FOR BRITISH ART, GIFT OF CHAUNCEY
BREWSTER TINKER

*A Treatise of Human Nature: Being an Attempt to introduce
the experimental Method of Reasoning into Moral Subjects.*
Vols. I and II, London: Printed for John Noon, 1739; Vol.
III, London: Printed for Thomas Longman, 1740.

First edition in three volumes. Hume expected this early work, to
which he had given 10 years of his life, to be a literary and philosophi-
cal sensation and was hugely disappointed with its non-reception: "It
fell dead-born from the Press." In later perspective, of course, it is seen
as the cornerstone and masterpiece of the Enlightenment, the most
important philosophical treatise of the century, and the greatest and
most comprehensive expression of Hume's philosophical doctrine.
"In it he uses the experimental method of Newton, on innovation in
moral subjects resulting from his own discovery, and he meant to be
known as the Newton of the human mind" (Duval and Hamilton).

LENT BY THE LILLY LIBRARY, INDIANA UNIVERSITY, BLOOMINGTON

Dialogues Concerning Natural Religion. London: 1779.

First edition. Hume had written the *Dialogues* by 1751 but suppressed
them on the advice of friends. He wished to entrust posthumous pub-
lication to his great friend, Adam Smith, who eventually demurred:
Hume then left the manuscript to the care of his nephew, also David
Hume, who saw the work through to press.

The *Dialogues* attracted little of the hostility that Hume's other
works on religion had provoked during his lifetime. Indeed, it is an in-
dication of the era's tolerance that the eminent divine, Hugh Blair,
wrote in a letter to the publisher Strahan (who had refused to print the
work): "As to D. Hume's *Dialogues*, I am surprised that though they
have been published for some time, they have made so little noise.
They are exceedingly elegant. They bring together some of his most
exceptionable reasonings; but the principles themselves were all in his
former works."

LENT BY DUVAL & HAMILTON

Thomas Reid

(1710–1796)

Thomas Reid was born at Strachan, Kincardineshire, where his father was the parish minister. On his mother's side, his uncle was the great Scottish astronomer and mathematician, David Gregory (1661–1708), Savilian Professor at Oxford. Thomas Reid read philosophy at Marischal College, Aberdeen, and then divinity. He was presented as minister to a parish where disputes regarding patronage had made the parishioners so hostile that one of Reid's uncles is said to have guarded the pulpit steps with a sword. A modest and benevolent man, Reid made a success of his ministry while at the same time continuing his speculative studies.

In 1751, Reid became Professor of Philosophy at King's College, Aberdeen, where his course of lectures included mathematics and physics as well as logic and ethics. Reid founded the Philosophical Society, nicknamed the Wise Club. They met weekly at the Red Lion Inn where Hume's *Treatise* provided much of the subject matter for discussion. In fact, Reid's *Inquiry into the Human Mind* (1764) owes much to these weekly exchanges. Its successful publication probably led to his election to the Chair of Moral Philosophy at Glasgow from which Adam Smith had just resigned. Reid modestly credited much of his own philosophical theory to the arguments of Berkeley and Hume. Among Reid's distinguished colleagues were Joseph Black (1728–1799) and John Millar (1735–1801).

Reid is the leading representative of the "Common-Sense" School. "Reid has been called the father of the Scottish School of Philosophy, that specific product of the Scottish genius in the reign of abstract thought" (Duval and Hamilton). With its vigor and acuity, this School provided a concrete working system, and was destined to exercise a profound influence in Italy, Germany, and especially France, where, for the best part of the 19th century it was the officially recognized philosophy of the colleges. Goethe praised the teaching of the Scottish School as expounded by Reid and Dugald Stewart (1753–1828) who was Reid's pupil and successor.

An Inquiry into the Human Mind, on the Principles of Common Sense. Edinburgh: Printed for A. Millar, London; and A. Kincaid and J. Bell, Edinburgh, 1764.

First edition. In this, his first book, Reid was the first to challenge the assumption made by Locke, accepted by Berkeley, and developed by Hume, that a given idea depends wholly upon the particular sensation or thought of which it is the object. Reid's "Common-Sense" view was that our perception of the external world is intuitive and that the objects of perception are real and not images.

Long considered as the standard refutation of Hume's skepticism, this book is important–apart from its own merits–because with the exception of a few contemporary reviews and a critical though friendly reference from Lord Kames, it is the first serious notice of Hume's *Treatise*. Through the efforts of Hugh Blair, Hume read part of Reid's manuscript and a friendly correspondence between Hume and Reid began.

LENT BY THE NEWBERRY LIBRARY, CHICAGO

Sir James Steuart Denham
(1712–1780)

The political economist was born at Edinburgh, entering the University there when he was just 13 to study law, following in the footsteps of his father who was a Solicitor-General of Scotland. Sir James was later admitted as a member of the Faculty of Advocates and, as was then the custom, set out to travel on the Continent where he met prominent Jacobites. In Rome, the exiled Stuarts showed him such kindness that he became firmly attached to their cause.

Steuart was in Edinburgh when Prince Charles Edward occupied the city and joined him at once, sailing to France in the Prince's service. He was in Paris when the uprising was crushed at Culloden. With return to Scotland impossible, he travelled in various countries, occupying himself with numerous studies and a pleasant social routine until 1763 when he was permitted to return to his homeland. Steuart retired to his family estate at Coltness to prepare his great work, *An Inquiry Into the Principles of Political Economy*.

On the death of his relative Sir Archibald Denham in 1773, Steuart obtained the estate of Westshield on the condition that he take the name of Denham.

An Inquiry into the Principles of Political Oeconomy. . . .
London: Printed for A. Millar, 1767.

First edition in two volumes. The first book in English that could be
considered a systematic or complete view of the subject. Steuart had
set himself a goal of covering all the major branches of economy and
his views are of value. His style, described as "tedious and perplexed,"
prompted Adam Smith to observe that "he understood Sir James's
system better from his conversation than from his volumes." In
Smith's *Wealth of Nations*, published nine years later, there is no refer-
ence to Steuart's treatise.

LENT BY THE SELIGMAN COLLECTION, THE RARE BOOK AND MANUSCRIPT
LIBRARY, COLUMBIA UNIVERSITY

John Home
(1722–1808)

Chiefly remembered as a playwright, John Home was born at Leith,
educated at the University of Edinburgh, and became a Presbyterian
minister. He was a central figure of the Edinburgh literati and an inti-
mate friend of David Hume who was a kinsman.

Home was enlisted by the government forces to defend Edinburgh
against Prince Charles Edward; he was present at the Battle of
Falkirk.

He went to London in connection with a production of his play,
Douglas, and became Secretary to Lord Bute and tutor to the Prince of
Wales, later George III. It is not surprising that Home's *History of the
Rebellion*, written in 1802, reflects a decidedly Hanoverian view.

John Home, Esq.

A. Birrell after Sir Henry Raeburn (1756–1823)
Engraving
33.7 x 25.4 cm. (13¼ x 10 in.)

LENT BY THE YALE CENTER FOR BRITISH ART, THE PAUL MELLON
COLLECTION

*Douglas: A Tragedy as it is acted at the Theatre-Royal in
Covent Garden.* Edinburgh: Printed for G. Hamilton &
J. Balfour, W. Gray & W. Peter, 1757.

First Edinburgh edition. A London edition was also printed simulta-
neously and in fact appeared several days earlier than the Edinburgh
version. Variations occur between both editions. Most significantly,
different prologues were printed for each. *Douglas* was first performed
in Edinburgh in 1756 and when the curtain fell on a thundering ova-
tion, an exultant voice cried out from the gallery: "Where's your
Wully Shakespeare noo!" A year later, with Peg Woffington at Lon-
don's Covent Garden, *Douglas* became an immediate success and even
70 years later, Mrs. Siddons chose the part of Lady Randolph in
which to make her farewell appearance. Based on the old Scottish bal-
lad *Gil Morris* and colored by Gothic-Romantic imagery, *Douglas* had
great appeal and played year by year to packed houses.

Apart from some disparaging remarks from Dr. Johnson, the play
met with critical approval. Writing to Horace Walpole, Thomas Gray
said of the author that he "seems to have retrieved the true language of
the stage, which has been lost for a hundred years. . . ." At a later date,
Scott found of another scene that it "has no equal in modern and
scarcely a superior in ancient drama."

Traditional lore has it that the dress rehearsal took place with David
Hume as the young hero Glenalvon; Hugh Blair, Alexander Carlyle,
Adam Ferguson, John Home, and William Robertson had other
parts; in the audience were such worthies as Lord Elibank, Lord
Kames, and Lord Monboddo.

The ruling party of the Kirk was outraged; the Presbytery was op-
posed on principle to theatrical representations. That *Douglas* was
written by a minister and attended by other ministers only made the
matter worse. A war of pamphlets ensued. Anticipating official ac-
tion, Home resigned his living; the Edinburgh Presbytery published
an *Admonition and Exhortation* and brought formal accusations against
Home and others. The minister and man of letters, Alexander Car-
lyle, was also prosecuted.

David Hume dedicated his *Four Dissertations* to John Home. His
dedicatory remarks, which were an indictment of intolerance, further
inflamed an angry Presbytery and stepped up the war of pamphlets.
Public opinion had been fully engaged and the Enlightenment's prin-
ciples of free expression were strengthened.

LENT BY THE G. ROSS ROY COLLECTION, THE THOMAS COOPER LIBRARY,
UNIVERSITY OF SOUTH CAROLINA

James Burnett, Lord Monboddo
(1714–1799)

One of the great learned eccentrics of the Scottish Enlightenment, James Burnett was born on the family estate of Monboddo in Kincardineshire. He was educated at King's College, Aberdeen, and he proceeded to Edinburgh and Gröningen for legal studies. Burnett rose steadily through the legal ranks to become a Lord of Session in 1767, taking the title Lord Monboddo. Known as a profound lawyer and an upright judge, he held opinions that were often those of the minority but none of his judgments was ever reversed by the House of Lords (Duval & Hamilton). One of his personal peculiarities noted in the courtroom was that instead of sitting on the bench with his fellow judges, he always took his seat underneath with the clerks.

Edinburgh's social and intellectual life claimed him. He was a supporter of the theatre, a member of the debating club, the Select Society, and through his "learned suppers," a friend of the leading men in all areas of thought. James Boswell was for many years an especial friend and confidant, introducing Dr. Johnson to Monboddo in 1773.

Monboddo's first work, *Of the Origin and Progress of Language*, created a sensation when the initial volume appeared in 1773. The author's remarkable prevision of future theories as to the origin of man, and his descent or ascent from lower types brought attacks from all sides: James Beattie found it "odious" and *The Edinburgh Magazine and Review* poured scorn on the work to the extent of 64 pages. Monboddo's other noted work, *Antient Metaphysics*, appearing in six volumes between the years 1779–1799, was written mainly to expose the teachings of Locke and Hume whose philosophy Monboddo detested. His work praised the idealism of the ancient Greek philosophers so dear to the author's heart.

Lord Monboddo's eccentricity has been stressed to the exclusion of his real achievements. He enjoyed considerable prestige in London, which he visited once a year until he was 80, travelling on horseback and attended by only one servant. As the ancients had not used carriages, Monboddo disdained them as "engines of effeminacy and idleness." He frequently attended court in London and was received with special favor by George III.

Of the Origin and Progress of Language. Edinburgh: Printed for A. Kincaid & W. Creech, and T. Cadell, London (1773, 1774, 1776, 1787, 1789, 1792).

First edition in six volumes. Scientific experimentalism is the keynote of *The Origin*. In this extraordinary work, Monboddo discusses the origin of ideas and the beginning of language: He held that man was originally an animal without speech, reason, or affection, and not terribly distinct from the orang-outang; that men in the Nicobar Islands had tails; and that all the higher attainments of the human race were the results of long experience, continued struggle, and artifice.

Dr. Johnson stated: "Other people have strange notions, but they conceal them. If they have tails, they hide them; but Monboddo is as jealous of his tail as a squirrel." Today, Monboddo is more thoughtfully regarded as a pioneer in the study of the orgin and transmission of language, and as a virtual evolutionist who anticipated the work of Charles Darwin (1809–1882).

LENT BY THE LILLY LIBRARY, INDIANA UNIVERSITY, BLOOMINGTON

Hugh Blair
(1718–1800)

Hugh Blair was the son of an Edinburgh merchant. A graduate of Edinburgh University, he met with early success as both preacher and teacher. In 1754, he was appointed minister of the High Church, a charge he maintained throughout his life. So great was the success of his university lectures that the town council founded a Chair in Rhetoric and Belles Lettres to which he was appointed. By the time his lectures were published in 1783, his reputation (and his vanity) had grown until he was the undisputed critical arbiter in Edinburgh. John Home brought him his *Douglas* and Hume brought him his *Essays*. Dr. Blair encouraged Macpherson to publish his *Fragments* in 1760 and continued to support their authenticity with more zeal than discretion. Almost 30 years later his encouragement meant much to Burns. Blair's works were translated into French and were influential there.

He enjoyed a close friendship with Hume, the Reverend Dr. "Jupiter" Carlyle, Adam Ferguson, Adam Smith, and others and with them was a member of the famous Poker Club. Blair's sermons were collected and first published in 1777; they enjoyed an unprecedented

popularity. They were standard library furnishing even for Dr. Johnson: "I love Blair's sermons, though the dog is a Scotsman and a Presbyterian and everything he should not be. I was the first to praise them."

Lectures on Rhetoric and Belles Lettres. London: Printed for W. Strahan, T. Cadell; and W. Creech, Edinburgh, 1783.

First edition in two volumes. Blair stated in a note that he had borrowed some ideas for this work from a manuscript by Adam Smith, who had lectured on rhetoric for a number of years. Blair's book reflects the Edinburgh literati's obsession with style. Acutely aware of the "Scoticisms" in his own speech, he admired the Augustan prose of Addison and Swift, to which he directed his students "as a proper method of correcting any peculiarities of dialect." Robert Heron in his *Observations Made in a Journey through the Western Counties of Scotland* (1792) observed: "I know not that any Professor of Rhetoric and Criticism ever contributed more to the Reformation of Taste in a Nation than Dr. Blair has done. . . . Under him a School of Taste and Eloquence has been formed which has diffused a skill in elegant composition and Taste to relish it, through all Scotland."

J. H. Millar claimed that one of "the mischiefs which sprang from the painful and sedulous aping of southern writers [was that] a terrible standard of 'eloquence' was set up which dominated Scotland for a hundred years."

Adam Smith
(1723–1790)

Adam Smith was born in Kirkaldy, Fife, where his father had been Controller of Customs. Adam's birth occurred shortly after his father's death, and, an only child, he was raised by his mother, to whom he was exceptionally close. Adam was said to have been carried off at about the age of three by gypsies but was returned not long afterwards. He studied at the University at Glasgow, where he showed an early leaning toward mathematics and philosophy as a student of Francis Hutcheson. In 1740, an award led him to Balliol College, Oxford, after which he returned to Edinburgh where he lectured and became part of the Edinburgh literati; Adam Ferguson, Hugh Blair, and

the historian William Robertson were especial friends. Smith was appointed to the Chair of Logic at Glasgow in 1751 and the following year transferred to its Chair of Moral Philosophy. His lectures were extremely popular, drawing crowds of students and Glasgow citizens. He held his university post until 1764 when he left to spend two years in Paris and Geneva as tutor to the third Duke of Buccleuch. In Paris, Smith enjoyed not only David Hume's friendship but also that of Hume's influential circle of friends, including Voltaire whom Smith greatly respected.

On his return to Scotland, Smith, said to have been "disappointed in an early and long attachment to a lady," settled down at Kirkaldy with his mother and a lady cousin, and wrote his influential study, *The Wealth of Nations*. It was published in 1776 in London where Smith often met with Benjamin Franklin to discuss his work. In 1778, he was appointed Commissioner of Customs and moved to Edinburgh with his family. Smith was President of the Royal Society of Edinburgh as well as a member of the Oyster Club along with his friends the scientist Joseph Black and the geologist James Hutton. Smith was honored with the rectorship of Glasgow University in 1787. He was also a patron of the inventor James Watt.

A theist, Adam Smith supported his friend David Hume in the *Douglas* controversy, though he declined Hume's request to publish posthumously Hume's controversial *Dialogues*.

Adam Smith

William Holl (1771–1838) after James Tassie (1735–1799)
Stipple Engraving
22.2 x 17.8 cm. (8¾ x 7 in.)

LENT BY THE YALE CENTER FOR BRITISH ART, THE PAUL MELLON
COLLECTION

The Theory of Moral Sentiments. London: Printed for A. Millar and A. Kincaid and J. Bell, in Edinburgh, 1759.

First edition. Written when Smith was Professor of Moral Philosophy at Glasgow, this book is a summation of the philosophy that he had learned from his teacher Francis Hutcheson, namely that happiness is quantitative. It also emphasizes the part played by *feelings* in determining man's moral behavior (Royle). Smith's book offers a view of *sentiment* similar to the one expressed by Henry Mackenzie in a later publication, *The Man of Feeling*.

Smith's *Theory* was a great success, bringing him recognition as an author and eliciting high praise from David Hume.

An Inquiry into the Nature and Causes of the Wealth of Nations. London: W. Strahan and T. Cadell, 1776.

First edition in two volumes. Presentation copy with Smith's inscription, "To the Count de Sarsfield, from the Author."

This classic work is the basis for modern political economy. Smith's simple belief that government should not interfere with free-market practices had an immediate political impact and has since exercised enormous influence on philosophers and statesmen. Smith's theories, of course, underpin the doctrine of capitalism and they influenced Victorian attitudes toward the free-trade movement.

Adam Ferguson
(1723–1816)

Adam Ferguson was born to the parish minister and his wife at Logierait in Perthshire and took his degree at St. Andrews. Intended by his father for the ministry, he was appointed chaplain to the Black Watch regiment and was present at the Battle of Fontenoy in 1745. His sentiments were anti-Jacobite and, though a Gaelic-speaking Highlander, he supported the government during the Jacobite rising that same year.

With the help of his influential friends among the Edinburgh literati, Ferguson succeeded David Hume as Librarian of the Advocates Library. In 1759, he accepted the offer of the Chair of Natural Philosophy at Edinburgh where he taught physics until he moved to the Chair of Moral Philosophy, a post he held for some 20 years. He was a popular lecturer, drawing crowds of students and visitors. Faced with a diminishing income, Ferguson interrupted his tenure to accept the offer, made at the recommendation of Adam Smith, to travel for two years on the Continent with the young third Earl of Chesterfield; this arrangement included a lifetime annuity for Ferguson.

As a central figure in Edinburgh's intellectual circle, Ferguson, described by the jurist Lord Cockburn as "domestically kind" but "fiery as gunpowder," enjoyed a lively social life. A founding member of the

Poker Club and The Royal Society of Scotland, he dined regularly with his close friend the scientist Joseph Black. At university, he was a great influence on his brilliant student and successor, Dugald Stewart. Ferguson sided with Macpherson in the Ossian controversy, and with John Home in his production of *Douglas*, which Ferguson justified on theological grounds in his pamphlet, *On the Morality of Stage Plays*.

In 1786, at his home Sciennes House, the famous meeting between Robert Burns and the young Walter Scott took place.

Perhaps best known in his own time for his *History of the Progress and Termination of the Roman Republic* (1782), his other works, *Institutes of Moral Philosophy* (1769) and *Principles of Moral and Political Science* (1792), were also successful and were translated into several European languages. The latter had a profound influence on German historical studies. His *magnum opus* remains *An Essay on the History of the Civil Society* (1767).

An Essay on the History of the Civil Society. Edinburgh: Printed for A. Millar & T. Cadell in the Strand, London; and A. Kincaid & J. Bell, Edinburgh, 1767.

First edition. This book is one of the first to stress the sociological aspect of man, for which reason many consider Ferguson to be the first proper sociologist. Ferguson eschewed Hobbes' and Rousseau's theories of natural man, allying himself instead with Montesquieu, who believed that the history of man had to be studied in relation to the society and social institutions created by him. Divided into six parts– Human Nature, Primitive Nations, Policy and Arts, Consequences of the Development from the Advancement of Civil and Commercial Arts, the Decline of Nations and Corruption, and Political Slavery– Ferguson's treatise examines the progress and decadence in society, and also looks for a true criterion of civilization.

Interestingly, David Hume suggested to Ferguson that the *Essay* be suppressed, but it received great approbation upon publication.

PRIVATE COLLECTION

John Millar

(1735–1801)

John Millar was born in Lanarkshire where his father was the parish minister. He studied for the law at Glasgow, where he was an intimate

of James Watt (1736–1819), the inventor of the steam engine, and where he attended the lectures of Adam Smith. After completion of his studies, Millar spent two years with Lord Kames's family (through whom he met David Hume). Millar became a proponent of Hume's metaphysical doctrines and, though they were politically opposed, Hume placed his nephew under Millar's charge. Adam Smith also showed his esteem by sending his cousin to study under Millar.

Millar accepted the professorship of law at Glasgow "at the recommendation of Lord Kames and Adam Smith." He taught English and Scottish law and government there. Millar's predecessor, Hercules Lindsay, had lectured in English, despite a protest from the Faculty of Advocates, and Millar attracted and increased the number of students by adhering to this policy (DNB). Millar was an outstanding orator in the Literary Society of Glasgow, maintaining Hume's theories in opposition to Reid's.

A highly principled Quaker (for which he incurred much opprobrium), Millar held Whiggish opinions which made him conspicuous at a time when Scotland was chiefly in the hands of the Tories. He volubly hoped that the American struggle would end in independence for the colonies; he was in favor of parliamentary reform, though he opposed universal suffrage as leading to corruption; and he taught that the power of the crown had made alarming advances. He was also a zealous agitator against the slave trade.

Observations Concerning the Distinction of Ranks, or an Enquiry into the Circumstances which Gave Rise to Influence and Authority in the Different Members of Society. London: J. Murray, 1771.

First edition. Of a remarkably liberal tone, Millar's study of social rank covers class distinction, the history and condition of women, primitive society, and the relationship between parent and child, and master and servant.

Francis Jeffrey's father refused to allow his son to take Millar's course at university because of the professor's Whig teachings. Jeffrey, as a reviewer, however, found much to commend in Millar's writings (which were based on his lectures and showed the influences of Hume, Lord Kames, and Adam Smith).

LENT BY DUVAL & HAMILTON

James Beattie
(1735–1803)

Poet, essayist, and philosopher. Beattie was born in Kincardine to poor parents; his father died when James was a small boy and he was supported by his eldest brother who sent him to Marischal College, Aberdeen, where he was able to obtain a bursary. Beattie started out as a schoolmaster, gaining notice for his contributions to *The Scots Magazine*. His first book, *Original Poems and Translations* (1760), established his name in literary circles.

In 1760, somewhat to his surprise, he was raised "by the influence of a powerful friend" to the Chair of Moral Philosophy and Logic at Marischal College, a position he admirably filled for more than 30 years. He was also a member of the Wise Club.

His writings, particularly *An Essay on the Nature and Immutability of Truth* (1770) and his poem *The Minstrel* (1771), secured him a contemporary fame which today seems exaggerated. Beattie became a close friend of Lord Monboddo and was a frequent visitor to London where he enjoyed a high standing in literary and political circles. He was presented to King George III who conferred an annual pension on him.

With the exception of an address to the poet Alexander Ross, which Beattie wrote in Scots, he eschewed the vernacular. In 1787, he wrote *Scoticisms . . . to Correct Improprieties of Speech*. Originally produced to improve the speech of his students, it is an indication of the desire of many of the intellectuals of Beattie's time to speak correct, Augustan English.

Beattie was a strong supporter of James Macpherson, defending the authenticity of the Ossian poems.

An Essay on the Nature and Immutability of Truth; in Opposition to Sophistry and Scepticism. Edinburgh: Printed for A. Kincaid & J. Bell, 1770.

First edition. Beattie's first philosophical essay, one of the famous attacks on Hume, was an immediate success in England where Dr. Johnson and Burke proclaimed its true philosophy and where it provoked the remark in the House of Commons that "the Scots are not all free thinkers." In Edinburgh, however, the Essay produced a violent reaction, one of the few occasions on which Hume became publicly

angry, describing the book as a "horrible large lie in octavo," and its author, "that bigotted, silly Fellow, Beattie." Modern criticism sides with Hume.

It was the *Essay* with its diatribe against Hume which gave Beattie, remembered today for *The Minstrel*, the extraordinary success he enjoyed during his own lifetime.

James Beattie LL.D.

Thomas Gaugain (1748–1805) after Sir Joshua Reynolds (1723–1792)
Stipple Engraving
16.2 x 20.3 cm. (6⅜ x 8 in.)

The famous allegorical portrait by Reynolds depicts Beattie with the *Essay on Truth* under his arm; beside him is Truth, holding in one hand a pair of scales, and with the other thrusting down three figures (two of which are meant to represent Hume and Voltaire) emblematic of Prejudice, Skepticism, and Folly.

The Minstrel; or, the Progress of Genius. A Poem. Book the First. London: for E. & C. Dilly, and A. Kincaid and Bell, Edinburgh, 1771–1774.

First edition in two volumes. Of the first part, only 500 copies were printed and issued simultaneously in London and Edinburgh. It was an immediate success and a further four editions were issued in rapid succession. The second volume appeared in 1774.

The work for which Beattie is remembered today was written in Spencerian stanzas and was described by Beattie as "a moral and serious poem. In fashionable, high-flown Augustan tones, it is a poetic visionary's symbolic journey from chaos to a true understanding of art."

James Macpherson
(1736–1796)

Macpherson was born in Inverness-shire into a poor farm family with close connections to the clan chief. At the local school he showed such

promise that his relatives sent him to the University of Aberdeen. He went on to the University of Edinburgh and prepared for the ministry but decided instead to be a schoolmaster.

His lifelong interest in the Gaelic oral tradition of poetry led to his "translation" of Ossian's poems which assured him fame and wealth. The object of adulation, Macpherson was nonetheless accused of forging the poems himself. Dr. Johnson's scathing accusations in particular set off a violent quarrel, and the question of authenticity raged for years. Macpherson had collected original material—he used up to 15 original pieces—but he certainly "arranged" the works to fit 18th-century taste and added passages of his own.

He went on to the unlikely appointment of Secretary to the Governor of Florida. This did not suit him and he returned to London where he became a political writer and pamphleteer. At his own request and expense he was buried in Westminster Abbey.

Fragments of Ancient Poetry. Collected in the Highlands of Scotland, And Translated from the Galic or Erse language. Edinburgh: Printed for G. Hamilton and J. Balfour, 1760.

First edition. While living in Moffat as a tutor, Macpherson went to the bowling green one day where he met Dr. Alexander Carlyle and John Home. They expressed keen interest in ancient Highland poetry and Macpherson obliged them by reciting a few fragments of verse. The two men along with Adam Ferguson and Hugh Blair encouraged Macpherson to go on in this area of study, and *Fragments* was the fruit of their enthusiasm.

The Edinburgh literati cherished a cultural agenda that would ensure the greatness of "the auld Scottish nation." *Fragments* kindled their hopes that Scotland might possess a body of classical literature on a par with that of ancient Greece or Rome. Upon publication, this book was an instant success. It suggested the existence of great epic poetry by the legendary bard Ossian, the son of the 3rd-century hero, Fingal. Accordingly, Macpherson was commissioned to tour the Highlands and the islands to collect such spoken treasure.

LENT BY THE THOMAS COOPER LIBRARY, UNIVERSITY OF SOUTH CAROLINA

Fingal, An Ancient Epic Poem, in Six books; Together with several other Poems, Composed by Ossian the Son of Fingal.

Translated from the Galic Language by James Macpherson. London: Printed for T. Becket and P. A. De Hondt, 1762.

Also bound with *Temora* (1763) and *A Critical Dissertation on the Poems of Ossian, the Son of Fingal* (1763) by Hugh Blair. First editions of all three titles.

When published, *Fingal* met with "almost hysterical reviews" (Royle). *Temora* followed in 1763 and if *Fingal* had raised suspicions as to authenticity, *Temora* confirmed them. Despite such questions, Macpherson's works were an immense achievement; they were a major influence on the Romantic Movement in Scotland and especially in Germany where Goethe and Schiller admired and acknowledged their debt to the poems of Ossian. Napoleon kept the poems on his desk and professed they were his favorite reading. Other devotees were Scott, Byron, and Coleridge. *Ossian* contributed to the revival of antiquarian interest in Scottish border ballads and paved the way for the 19th-century fashion for all things Scottish.

PRIVATE COLLECTION

James Boswell

(1740–1795)

The biographer of Samuel Johnson. Descended from an old Scottish family of Auchinleck, Boswell studied at the University of Edinburgh and went on to study civil law at the University of Glasgow, where he attended Adam Smith's lectures. Boswell's feelings toward Scotland were mixed: although he was fiercely proud of his lineage and of the traditions and history of Scotland, he preferred the sophistication of London to provincial Edinburgh, and, like many of his fellow "enlightened" Scots, was eager to rid his speech of "Scoticisms." In 1760, Boswell ran off to London, his mind "filled with the most gay ideas—getting into the Guards, being about Court, enjoying the happiness of the *beau monde*, and the company of men of Genius." Fortunately, Lord Auchinleck saw to it that his eldest son's ambition of being "shot at for three shillings and sixpence a day" was never realized. So it was that by 1762 a very healthy and vital James Boswell was thriving among the pleasures of London and Edinburgh society. He enjoyed the friendship of Lord Kames, Lord Hailes, and David Hume, who re-

ferred to him as "a friend of mine—very good humoured, very agreeable, and very mad."

Boswell's *annus mirabilis* came in 1763 when he met the Great Lexicographer, Samuel Johnson, in Thomas Davies' London bookshop. The young Scots lawyer, only 23 and with little notoriety to recommend him, felt rebuffed at first by Johnson, who was then basking in his fame as the author of the much acclaimed *Dictionary*. Davies assured Boswell that he had made a good impression on the irascible doctor, and within a little more than a month of that first meeting, Boswell and Johnson were dining together in the chop-houses and taverns of London. That two such incongruous individuals could have formed so solid and harmonious a friendship seems incomprehensible, but form it they did.

In August 1763, Johnson travelled to Harwich to see Boswell off on his Continental tour. Through his own terrier-like determination, Boswell obtained interviews with Jean-Jacques Rousseau and Voltaire. Talks with the Corsican patriot Pasquale Paoli provided much of the material for his stories in *The London Chronicle* and for his own *Account of Corsica, The Journal of a Tour to that Island and Memoirs of Pascal Paoli* (1768). Well-received by the critics, *An Account of Corsica* announced Boswell's confident handling of biographical narrative that years later would distinguish his *Life of Samuel Johnson* (1791) as the most engaging biography ever written in English.

In the spring of 1773, after 10 years of talk and planning, the pair set off together on their famous tour of Scotland and the Hebrides which Johnson documented in his *Journey to the Western Islands of Scotland* (1775) and Boswell in his *Journal of a Tour to the Hebrides, with Samuel Johnson* (1785).

Any youthful energies not devoted to law, literature, dissipation, or Dr. Johnson were directed toward romantic entanglements. Boswell chanced upon "little charmers" wherever he went and always found it impossible to resist their allure. Despite his tendency to philander, Boswell did find the perfect mate in his cousin Margaret Montgomerie of Ireland. She was not only a great beauty but, as a friend had described her to Boswell, also a lady of "nutritive conversation." Boswell married Margaret in 1769 and the relationship held true to the promise of marital felicity. In Boswell's own words: "It is such as nourishes me and like sweet milk, tempers me and smooths my agitated mind." The Boswells had four children, one of whom was Alexander, the renowned printer-publisher, antiquary, and songwriter.

Although an advocate by profession who practiced at the Scottish bar for 17 years, Boswell was by natural inclination a journalist. In addition to his Corsican contributions to *The London Chronicle*, he wrote a series of about 70 papers called *The Hypochondriack* between 1777 and 1783 for *The London Magazine*. Boswell's final years were marked by disappointing failures to obtain a seat in Parliament and to distinguish himself at the English bar. The publication of his two most masterful literary works, his *Journal of a Tour to the Hebrides* (1785) and his *Life of Samuel Johnson* (1791), temporarily boosted his flagging self-esteem. However, after the death of his wife in 1789, not even revived interest in him as a writer could prevent Boswell from drifting further into debt and dissipation, which no doubt induced an untimely end to his life and literary career. He died in London on 19 May 1795 at the age of 54.

James Boswell

John Jones (1745?–1797) after Sir Joshua Reynolds (1723–1792)
Mezzotint, 1786
37.8 x 27.7 cm. (14⅞ x 10⅞ in.)

LENT BY THE YALE CENTER FOR BRITISH ART, THE PAUL MELLON FUND

The Journal of a Tour to the Hebrides, with Samuel Johnson. London: Printed by Henry Baldwin, for Charles Dilly, in the Poultry, 1786.

Third edition revised and corrected; second issue with the map. Originally published in 1785, the third edition of the famous Johnson-Boswell tour of the Hebrides on display is of particular interest as it bears the inscription on the front flyleaf: "To James Boswell, Esq: Junior from his affectionate father The Author."

The great virtue of the *Tour*, as the late Frederick A. Pottle points out in his preface to the 1961 edition, was that "Boswell's greatest good fortune as imaginative journalist was to have met in Samuel Johnson a character that is as good as was ever invented by novelist. Thus, the literary superiority of the Hebridean journal may be established by the fact that it covers a period of Boswell's life where for one hundred and one consecutive days, he travelled, ate, talked and often slept in the same room with Samuel Johnson."

PRIVATE COLLECTION

The Life of Johnson. London: Printed by H. Baldwin for C. Dilly, 1791.

Fragmentary set of first proof sheets. MS. corrections by Boswell and Malone. Macaulay's acid commentary of 1832 fixed for three generations the official literary opinion on Boswell's talent as a writer: "If he had not been a great fool, he would never have been a great writer." Boswell's methodology explodes Macaulay's theory of the "inspired idiot," for it was anything but haphazard. He had been obliged, he tells us, to run half over London simply to verify a date. His proof-sheets and notes to the compositor for the *Life* further evidence his fastidious, professional concerns about accuracy and style.

A born notetaker and interviewer, Boswell used his journals as the raw material for his famous biography. The adulous Scotsman was forever pestering Johnson on all manner of things, with the general idea of directing conversation toward subjects that would elicit a memorable *bon mot* or two for posterity and his quarto notebooks. Occasionally, Boswell's method floundered with queries as ludicrous as, "What would you do, sir, if you were locked up in a tower with a baby?"

Nevertheless, Boswell's journalistic instincts on the whole served him well. All his patiently recorded incidents and impressions, which a traditional biographer would have dismissed as trifling and unimportant, imparted Boswell's work with the vibrancy and true color of everyday life. Boswell perceived that Johnson would appear at his most natural, with all his moods and failings, if depicted in the company of his contemporaries. Thus, Boswell not only painted an intimate, life-like portrait of Johnson but also presented a candid, panoramic view of 18th-century English society (Royle).

Recovery in this century of many of Boswell's private papers (from Malahide Castle in Ireland and Fettercairn House in Scotland) has allowed complete editions of the *Life* and the *Tour* to be published in 1934–1940 and 1936, respectively.

PRIVATE COLLECTION

Samuel Johnson
(1709–1784)

A Journey to the Western Islands of Scotland. London: Printed for W. Strahan; and T. Cadell in the Strand, 1775.

First edition, second issue. This is a description of the three-month trip taken by Samuel Johnson and James Boswell to Scotland and the Hebrides in 1773. Part of its historical importance may be reflected in Johnson's perceptions about the true nature of what was happening to Scotland at that time. His observations of the journey are tinged with sadness. After the Scots lost at Culloden in 1746, their land was subject to British rules and strictures. Johnson recognized that the whole region was, as a result, in the grip of a great decline.

A scholar of his age, Johnson was well known for scoffing at the contemporary craze for the picturesque. However, as biographer John Wain points out, Johnson enjoyed a tactile connection with the earth–on one occasion, he even emptied out his pockets so that he could roll down a hill. Despite his famous derogatory remarks about Scotland, he was not indifferent to his surroundings on this trip.

PRIVATE COLLECTION

Samuel Johnson in Travelling Dress

Thomas Trotter (1756–1803)
Engraving after a drawing by Trotter
25.3 x 17.8 cm. (10 x 7 in.)

LENT BY THE LEWIS WALPOLE LIBRARY, YALE UNIVERSITY, FARMINGTON, CONNECTICUT

Henry Mackenzie
(1745–1831)

"Born on the day when Prince Charles landed in 1745, he served as a literary page to the coterie of David Hume; became the most popular British novelist of a decade; wrote the best periodical essays and short tales of his century in Scotland; was the first important man of letters to greet the genius of Burns; started the literary career of Walter Scott; gave the first encouragement to Byron . . ." (Introduction to *Anecdotes and Egotisms*, H. W. Thompson). Indeed, Mackenzie occupied a unique position in Edinburgh society as a connecting link between successive generations. Mackenzie, the son of an eminent physician, was born in Edinburgh. Educated at the university there, his work in Exchequer Law was soon superceded by his work on a sentimental novel, *The Man of Feeling*, which was influenced by Sterne.

He wrote unsuccessfully for the stage but won acclaim for his many

other works especially as the instigator of and contributor to the weekly periodicals, *The Mirror*, begun in 1779, and *The Lounger*, first issued in 1785.

Mackenzie and his wife had a large family, and their home became a brilliant social center of the city's literary set. Mackenzie was one of the earliest members of the Royal Society of Edinburgh.

The Man of Feeling. London: Printed for T. Cadell, 1771.

First edition. The first sentimental novel. As has been remarked, "the book is moist with weeping." One critic counts 47 separate occasions of tears. Burns admired *The Man of Feeling* and prized it "next to the Bible."

LENT BY THE LILLY LIBRARY, INDIANA UNIVERSITY, BLOOMINGTON

Robert Fergusson
(1750–1774)

Robert Fergusson was born in Cap and Feather Close in Edinburgh where his father earned a modest living as an accountant. Robert received a bursary to study at the High School of Dundee and then at the University of St. Andrews where his gifts for satire and poetry came to the fore. His studies were cut short by the death of his father. Now the sole support of his mother and sister, he returned to Edinburgh where he took a job as an ill-paid copyist in a law firm.

His early writing of patriotic Scots verse appeared in Ruddiman's *Weekly Magazine, or Edinburgh Amusement.* He enjoyed the company of the taverns and drinking clubs and when illness and acute depression forced him from his job, his fellow members of the Cape Club offered their support. Overcome by religious delusions, he was removed to an asylum where he died at the age of 24 in conditions of neglect.

Fergusson was at his best when depicting human aspects of Edinburgh life; his poems express a sense of the liberalism of his time while his inner life was haunted by Calvinist terrors. "To an astonishing extent, the Scottish Enlightenment was precisely adapted to release these literary forces, i.e., free thinking, the anti-clerical, which had been suppressed or left dormant since the Reformation" (MacQueen).

Poems. Edinburgh: Printed by Walter & Thomas Ruddiman, 1773.

First edition of the poet's first and only book. "The model of great things to come" was R. L. Stevenson's description of these verses. Fergusson was the single most important influence on Robert Burns; a number of his poems provided the starting point for much of Burns' own poetry. In a moving tribute to Fergusson, Robert Burns commissioned a stone for his unmarked grave.

Robert Burns
(1759–1796)

The sublime poetry and songs of Robert Burns mark the high point in the popularity of 18th-century vernacular poetry. In his poetry, Burns caught and fixed the old Scotland as it existed just before the onset of the Industrial Revolution. Because he preserved so much of Scotland's past, and because he possessed the ingenious gift of stating the commonplaces of life in a way which makes them significantly memorable, Burns stands alone (Lindsay).

The poet was born on 25 January 1759 in a two-room thatched cottage at Alloway, near Ayr, where his parents, William and Agnes Burns, struggled on a series of poor farms. Robert endured desperately hard labor as a youth which very likely impaired his heart and nerves. Burns' brother Gilbert wrote that, "to the buffetings of misfortune, we could only oppose hard labor and the most rigid economy. . . . The anguish of mind we felt at our tender years . . . was very great." Their father was a loving man but a strict Calvinist who had the traditional Scots respect for education and saw to it that his children got the best available. Under the tutelage of the local schoolmaster, Burns read widely. He recalled that *A Collection of Songs* was his *vade mecum*. Another source of learning took place around the family hearth: "In my infant and boyish days," wrote Burns, "I owed much to an old woman [Jenny Wilson] who resided in the family, remarkable for her ignorance, credulity, and superstition. She had, I suppose, the largest collection in the country of tales and songs concerning devils, ghosts, fairies, brownies, witches, warlocks, spunkies, kelpies, elf-candles, dead-lights, wraiths, apparitions, cantraips, giants, enchanted towers, dragons and other trumpery."

At the age of 15, Burns not only "committed the sin of rhyme" but also was transported by the raptures of first love, "which at times have

been my only . . . enjoyment. . . . My heart was completely tinder, and was eternally lighted up by some goddess or other."

In 1788, Burns married Jean Armour with whom he had nine children. He finally escaped the harsh rounds of farming, if not the pinch of poverty, by obtaining an appointment as an exciseman. As such he moved to Dumfries where he spent the last years of his life. He died most likely from endocarditis contracted in childhood.

Robert Burns

Samuel Cousins (1801–1887) after Alexander Nasmyth (1758–1840)
Mezzotint, 1830
40 x 31.7 cm. (15¾ x 12½ in.)

LENT BY THE YALE CENTER FOR BRITISH ART, THE PAUL MELLON COLLECTION

Letter to Winifred Maxwell Constable. Ellisland, 16 December 1789.

In this autograph letter addressed to Lady Winifred Maxwell Constable, Burns writes of his family's loyalty to "the Cause" of the Stuarts.

PRIVATE COLLECTION

Poems, Chiefly in the Scottish Dialect. Kilmarnock: Printed by John Wilson, 1786.

The first edition of the poet's first book of which 612 copies were printed.

This provincial offering, eagerly picked up in the capital, was recognized in Henry Mackenzie's December 1786 review in *The Lounger*: "To the feeling and susceptible there is something wonderfully pleasing in the contemplation of genius, of that supereminent reach of mind by which some men are distinguished. . . . I know not if I shall be accused of such enthusiasm and partiality, when I introduce to the notice of my readers a poet of our own country, with whose writing I have lately become acquainted; but if I am not greatly deceived, I think I may safely pronounce him a genius of no ordinary rank. The person to whom I allude is Robert Burns, an Ayrshire plowman, whose poems were sometime ago published in a country-town in the west of Scotland, with no other ambition, it would seem, than to circulate among the inhabitants of the country where he was born, to obtain a little fame from those who had heard of his talents. I hope I shall

not be thought to assume too much, if I endeavor to place him in a higher point of view, to call for a verdict of his country on the merit of his work, and to claim for him those honours which their excellence appears to deserve. . . . Though I am very far from meaning to compare our rustic bard to Shakespeare, yet whoever will read his lighter and more humourous poems, will perceive with what uncommon penetration and sagacity this Heaven-taught plowman, from his humble and unlettered station, has looked upon man and manners."

Shown here is one of Burns' brilliant series of satires against the hypocrisy and rigid restraints of the *auld licht wing* of Calvinism. *The Holy Fair* traces its roots back to *Leith Races* by Robert Fergusson.

The poet's amorous adventures often brought him to the ignominy of the repentance stool and the condemnation of his parish. In fact, when this Kilmarnock edition was being published, the angry father of Jean Armour, who was well into her term with Burns' twins, had just brought suit against the poet for breach of promise. Burns in the meantime contemplated absconding to Jamaica with Mary Campbell (*Highland Mary*) as his wife.

PRIVATE COLLECTION

Wilt Thou Be My Dearie? Manuscript.

The autograph manuscript of this poem comprises two stanzas of nine lines each. It is addressed to Miss Janet Miller, daughter of Patrick Miller of Dalswinton, Dumfriesshire. Miller had been Burns' landlord when he was a farmer at Ellisland.

The copy of the poem is followed by a dedication to Miss Miller, also in the poet's hand: "To the sweet, lovely Girl who is the theme of the foregoing Song, this copy of it is presented as a mark of brotherly affection of unalterable regard—from the Author."

Burns' song was first published in Perry's *Morning Chronicle* on 10 May 1794.

PRIVATE COLLECTION

The Merry Muses of Caledonia; A Collection of Favourite Scots Songs, Ancient and Modern; Selected for Use of the Crochallan Fencibles. Say, Puritan, can it be wrong, To dress plain truth in witty song? What honest Nature says, we should do; What every lady does . . . or would do. [1799].

This is one of only two known surviving copies of the first edition of

Burns' bawdy verse. Lord Rosebery's copy, now on deposit at the National Library of Scotland, has a defective title page, making it impossible to read the date of publication. Though this copy is dated 1799, some gatherings are printed on paper dated 1800, leaving the actual publication date open to conjecture.

From his anthology work, Burns excised the peasant obscenities of an earlier, coarser age, but he preserved them in this personal collection. He enjoyed collecting bawdy folk songs and writing his own for circulation among his friends. In his Edinburgh days, he presented them to the Crochallan Fencibles, the Edinburgh drinking club whose fellowship he enjoyed. The tone is humorous: Burns looks on sex as the basic levelling element in the human comedy.

LENT BY THE G. ROSS ROY COLLECTION, THE THOMAS COOPER LIBRARY, UNIVERSITY OF SOUTH CAROLINA

Tam o'Shanter. Autograph Manuscript.

With the single great exception of *Tam o'Shanter*, written in 1791, the body of Burns' poetry had been written by the time he arrived in Edinburgh in 1787 to oversee the publication of the second edition of *Poems.*

This exuberant celebration of the fantastic and the grotesque is Burns' most sustained poetic effort and by common consent, one of the first and greatest narrative poems in the vernacular (Lindsay). In *Tam o'Shanter* and in *The Jolly Beggars*, Burns has moved far beyond the Enlightenment.

LENT BY THE PIERPONT MORGAN LIBRARY, NEW YORK

Francis Grose
(1731?–1791)

The Antiquities of Scotland. London: Printed for S. Hooper, 1789–1791.

First edition in two volumes. Having completed his *Antiquities of England and Wales*, the English antiquarian Captain Francis Grose set off for Scotland. There he lodged with Burns' nearest neighbor, Captain Riddel, where he and the poet became friends. Burns suggested that Grose include Alloway Kirk in his forthcoming volume and Grose agreed on the condition that Burns would provide a witch's tale.

This is the first appearance in book form of *Tam o'Shanter*; it had appeared two months earlier in *The Edinburgh Magazine.*

James Johnson
(1750–1811)

The Scots Musical Museum. Edinburgh: Printed and Sold by J. Johnson, 1787.

First edition. Six volumes, through 1803. As a songwriter, Burns' lyric gift was unsurpassed and Johnson's *Musical Museum* afforded the poet his opportunity in this field.

James Johnson is thought to have been a native of Ettrick. He was an engraver and music seller in Edinburgh who devised or introduced into Scotland a process of "striking music upon pewter" which revolutionized methods of printing music. This poorly educated man, whose spelling was atrocious, conceived the idea of publishing a collection of the lyrics and music of all extant Scots songs. He was a member of the Crochallan Fencibles, and it was probably there that he met Burns when the latter visited the capital in 1787. Johnson invited the poet's collaboration and Burns' enthusiasm eventually outdid his own. Thereafter, until his death, Burns was virtually the real editor, contributing about 160 songs of his own. Four volumes were published during the poet's lifetime with the sixth and last volume appearing in 1803.

As he had with Thomson, Burns refused payment, finding this "patriotic work" to be exactly to his taste. Alas, Johnson, like Burns, died impoverished and his widow was forced to remove to the workhouse where she died.

George Thomson
(1757–1851)

A Select Collection of Original Scotish Airs For the Voice. To each of which are added Introductory and Concluding Sym-

*phonies, & Accompanyments for the Violin and Piano Forte.
By Pleyel. With Select & Characteristic Verses by the most ad-
mired Scotish Poets, adapted to each Air; many of them entirely
new.* London: Preston & Sons, [1793–1799].

Four sets with engraved titles with alternating leaves of letterpress
songs and engraved music throughout, signed by George Thomson,
the compiler. Second edition (actually a reissue of the first edition) of
the first set; first editions of sets 2–4.

Thomson had the idea of marrying Scots verse to musical accom-
paniments. In all, six Scottish volumes appeared from 1793 through
1841. Burns wrote to Thomson: "You cannot imagine how much this
business of composing for your publication has added to my enjoy-
ments." In another letter to Thomson, Burns explained his method of
adapting verse to melody: ". . . until I am compleat master of a tune, in
my own singing, (such as it is) I never can compose for it. My way is: I
consider the poetic Sentiment, correspondent to my idea of the musi-
cal expression; then chuse my theme; begin one Stanza; when that is
composed, which is generally the most difficult part of the business, I
walk out, sit down now and then, look out for objects in Nature
around me that are in unison or harmony with the cogitations of my
fancy and workings of my bosom; humming every now and then the
air with the verses I have framed; when I feel my Muse beginning to
jade, I retire to the solitary fireside of my study, and there commit my
effusions to paper; swinging, at intervals, on the hind legs of my el-
bow-chair, by way of calling forth my own critical strictures, as my
pen goes."

In fact, songwriting had become essential to Burns and he regarded
this work to be his most valuable. He worked on the songs up until the
last few days of his life, writing to Thomson in April of 1796: "Almost
ever since I wrote you last, I have only known Existence by the pres-
sure of the heavy hand of Sickness; and have counted time by the
repercussions of PAIN! Rheumatism, Cold and Fever have formed, to
me, a terrible Trinity in unity, which makes me close my eyes in mis-
ery, and open them without hope." He went on composing, providing
Thomson with about 114 songs of which over 60 appeared written es-
pecially for this work. All but one were previously unpublished. "No
exact figure can be given because in many instances songs by other
people which Burns merely claimed to have polished, he so subtly and
surely transformed that he clearly deserves the main share of the

credit for their immortality" (Lindsay). Although he could have used the money, Burns refused payment for his poems, declaring that the work was "either above or below price."

In this volume appear such well-known works as *O, My Love is Like a Red, Red Rose; Auld Lang Syne; Scots Who Hae Wi' Wallace Bled; and O, Whistle and I'll Come To You, My Lad.*

PRIVATE COLLECTION

Sir John Sinclair
(1754–1835)

Born at Thurso Castle, Sinclair was a descendent of the Earls of Caithness and Orkney. He was educated at the Universities of Edinburgh, Glasgow, and Oxford, and was a member of Parliament for Caithness. He was first president of the Board of Agriculture and his most important work by far is his *Statistical Account of Scotland.* Sinclair was the earliest modern statistician and he was responsible for introducing the word "statistic" into the English language.

His work was rooted in his genuine concern for rural reform.

The Statistical Account of Scotland. Drawn Up from the Communications of the Ministers of the Different Parishes. Edinburgh: Printed and Sold by William Creech, 1791.

First edition in 21 volumes. This work is the first systematic attempt to compile social and economic statistics for the whole country. Sinclair solicited all the parish ministers of Scotland for information on the natural history, population, and productions of their parishes. The result of these inquiries was published at various periods over the next 10 years, and the value of the work was recognized by Jeremy Bentham, Malthus, and Washington. It has preserved for us a vivid record of life in Scotland at the close of the 18th century.

Original Burns material in Volume III is shown here. Burns and his close friend and neighbor at Ellisland, Robert Riddell, wrote letters to advise Sinclair of the Monkland Friendly Society, a lending library founded by both men "to store the minds of the lower classes with useful knowledge." Burns was treasurer, librarian, and censor (!) to this little society. He has signed his letter to John Sinclair, "A Peasant."

PRIVATE COLLECTION

William Smellie
(1740–1795)

Printer, naturalist and antiquary, Smellie was Edinburgh born and bred and a prominent Enlightenment figure.

He left grammar school for an apprenticeship in printing, a craft in which he excelled. He combined studies at the university with his printing work and enjoyed membership in the Philosophical (afterwards the Royal) Society of Edinburgh. Smellie was a foundermember of the Society of Antiquaries and the Newtonian Club, and a Keeper of the Museum of Natural History.

With Dr. Gilbert Stuart in 1773, he began the monthly periodical, *The Edinburgh Magazine and Review.* His firm of Creech & Smellie produced Burns' second enlarged edition of the *Poems* in 1787. Burns wrote of Smellie: "And though his caustic wit was biting rude, His heart was warm, benevolent and gude."

Encyclopædia Britannica; or A dictionary of arts and sciences, compiled upon a new plan. . . . By a society of gentlemen in Scotland. Edinburgh: Printed for A. Bell and C. MacFarquhar, 1771.

The *Encyclopædia Britannica* had its beginnings in Diderot's *Encyclopédie* which appeared in 1751 in Paris and which had so well expressed the aims of the European Enlightenment: to espouse rational thinking and to dismiss faith and superstition.

Three Edinburgh printers were determined to share this new market: Andrew Bell, Colin MacFarquhar, and William Smellie. They issued a prospectus in 1768 for the *Encylopædia Britannica.* To Smellie fell the task of editing the work; he wrote most of the articles, clearly demonstrating his love of plain expression, which was also a hallmark of the prose style of the Scottish Enlightenment.

The *Encyclopædia* was published serially, with the first bound volume, *Aa to Bzo,* appearing in 1769; *Caaba to Lythrum* in 1770; and *Macao to Zyglophyllum* in 1771. It ran to 2,659 pages and included 160 copper-plate illustrations. The entire set cost £12.

Smellie set the tone of the work in his preface: "Utility ought to be the principal intention of every publication. Wherever this intention does not plainly appear, neither the books nor the authors have the

smallest claim to the approbation of mankind." He intended the book to reach as many people as possible which, given the many editions that have followed the original, it has.

LENT BY THE LEWIS WALPOLE LIBRARY, YALE UNIVERSITY, FARMINGTON, CONNECTICUT

THE INDUSTRIAL AGE

THE technological advances begun in the 18th century with the Industrial Revolution would transform Scotland's essentially agrarian economy into a world-class industrial power in the 19th. While Edinburgh retained its primacy as the "Athens of the North," Glasgow and its environs became the Hephaestian forge of the British Empire by the mid-century mark. James Watt's patented improvements on the steam engine in the late 18th century, coupled with the invention of the hot-blast furnace in 1828 by fellow Scot James Beaumont Neilson, helped expand and integrate metallurgy, steel production and ironworks.

Ill-prepared for rapid and massive industrialization, the public resources and services of the Lowland cities were strained to the point of collapse. Inadequate water supplies and drainage caused frequent and deadly outbreaks of cholera and typhus. Mortality rates among children swelled so that by the 1850s, one-half of all children under five died.

The literature of the period largely reflects a society convulsed by fundamental change that, more often than not, adversely affected the lives of most Scots. Carlyle, Galt, and Hogg were among the first to recognize the social ills of the industrial age; and their work chiefly grapples with the religious and philosophical crises precipitated by the era's ethic of materialism. By the 1880s, Scotland had assimilated the *Zeitgeist* of Victorian England yet tenaciously preserved a kernel of cultural specificity. "Common-Sense" realism, a legacy of the Enlightenment, and a nostalgic yearning for the familiar comfort of time-worn traditions polarized the Scottish psyche. This duality in the national consciousness found its most trenchant, if allegorical, expression in many of the novels of the period. No fiction could long mask the grim reality of urban life, and the bitter disillusionments and frustrations of the working class finally exploded at the turn of the century in the social realist writings of George Douglas and John Davidson, Scotland's first angry young men. Similarly, a new female voice was not heard in literature until the early 20th century when women were given the right to vote and the First World War claimed the lives of some 74,000 Scotsmen, leaving women the chief caretakers within the home and society. Representative of this change are emancipated survivors like Grassic Gibbon's heroine, Chris Guthrie.

Despite the early successes and stature of poets like Scott and Byron, the 19th century was the age of prose. Gaelic verse faded from the fore, owing in part to the landowners' policy of the Clearances. The forced eviction of Highland crofters (tenant farmers) to make way for more profitable sheep grazing uprooted whole villages, disrupted linguistic traditions, and virtually dissolved the once-powerful clan system. The Education Act of 1872 further weakened the hold of Scoto-Gaelic dialects on the national literature.

Inspired in part by the Irish Home Rule Act as well as a surge of patriotism following the First World War, the Scots language, with which the national psyche is so closely identified, was rejuvenated as a contemporary idiom in the mid-1920s. The movement, known as the Scottish Renaissance, was spearheaded by Hugh MacDiarmid who was a major influence on many notable poets and novelists throughout the latter half of this century.

Mrs. Grant of Laggan
(1755–1838)

Anne Grant was born at Glasgow. Her father, Duncan Macvicar, described by his daughter as a "plain, brave, pious man," was a farmer before obtaining his commission in the army. When Anne was two, the family sailed to America where her father fought at Ticonderoga. Anne and her mother remained in Albany where Anne became a favorite with the Schuyler family. Her *Memoirs of an American Lady*, published in 1808, celebrated the widow of Colonel Philip Schuyler whose kindness had deeply impressed Anne.

In 1768 the family returned to Scotland. Anne married the barrack chaplain and minister of Laggan. She performed the duties of a clergyman's wife in a Highland parish, learning Gaelic, genuinely admiring the people, learning their folklore and striving to ameliorate their conditions. Her husband's premature death in 1801 left her destitute and she determined to turn her literary tendencies into her livelihood. This she did, supporting her eight children on the proceeds of her published work. Her *Letters from the Mountains* appeared in 1806 and was an immediate success. In 1810, Mrs. Grant moved to Edinburgh where she augmented her resources by taking in young lady boarders.

Her literary reputation was an introduction to distinguished Edin-

burgh society; Lockhart speaks of her as "a shrewd and sly observer." Scott admired her and Jeffrey reviewed her books in *The Edinburgh Review*. De Quincey noted that she was "an established wit." She was a high Tory known for her sharp tongue and respected for her considerable critical discernment. In 1826, Scott, Mackenzie, and other friends procured her a pension which provided that her last years would be comfortable.

Poems on Various Subjects. Edinburgh: Printed for the author by J. Moir, and sold by Longman and Rees, London; ... 1803.

First edition in original boards. Large uncut copy. The author's first book, these poems reveal her lifelong fascination for Highland lore; there is great attention to detail in her extensive notes and her poetry abounds with local allusions, geographic detail, and Gaelic phrases. Never far from the surface, however, is the world of ruins and witchcraft, all of which suited the tastes of a literary public delighted by the writings of Ossian and transported by the ideal of the "noble savage" and the celebrations of the natural world.

PRIVATE COLLECTION

Joanna Baillie
(1762–1851)

Dramatist and poet Joanna Baillie was descended from an ancient Scottish family who claimed Sir William Wallace as an ancestor. She was born in Lanarkshire, the daughter of a minister. Although surrounded by a wild and beautiful countryside, in the manse, "repression of all emotions seems to have been the constant lesson." At the age of 10, Joanna was sent to a school in Glasgow where she showed great intellectual ability.

On moving to London with her family, Joanna wrote her first collection of poems. She had a sure sense of Scots and also wrote a number of memorable songs. Although she was extremely popular in her own time, she is ranked as a minor poet today.

Joanna Baillie enjoyed a greater reputation as a dramatist and her work was admired by Sir Walter Scott. In 1798 she published anonymously the first in a series called *Plays of Passion* which received critical acclaim. Sir Walter Scott was suspected as author. One of the

plays, *De Montfort*, was produced by John Kemble in 1800 with himself and Mrs. Siddons in the leading roles. Perhaps her greatest success was *The Family Legend* which was based on a Highland tradition; this tragedy had a prologue by Sir Walter and an epilogue by Henry Mackenzie. It was produced in Edinburgh under Scott's auspices and enjoyed a solid success. Baillie's acquaintance with Scott ripened into an enduring friendship; he paid tribute to "the immortal Joanna" in his introduction to the third canto of *Marmion*.

Joanna Baillie died in London at the age of 89.

Metrical Legends of Exalted Characters. London: Longman, Hurst, Rees, Orme, and Brown, 1821.

A successful work which features Scottish lives and lore.

LENT BY THE COLEMAN PARSONS COLLECTION, THE RARE BOOK AND MANUSCRIPT LIBRARY, COLUMBIA UNIVERSITY

Susan Edmonstoune Ferrier
(1782–1854)

Susan Ferrier was born in Edinburgh, the youngest of 10 children. Her father was a Writer to the Signet and the legal agent of the Duke of Argyll, later becoming Clerk to the Court of Session with Sir Walter Scott. As a child, Susan Ferrier enjoyed the friendship of the literati in Edinburgh and the aristocracy in Inverary, the seat of the Argylls. The author was also a good friend of Sir Walter Scott, visiting him on several occasions. Lockhart describes the delicacy with which she helped Scott over the gaps in conversation caused by his failing memory. In his diary, Scott calls her "simple, full of humour, and exceedingly ready at repartee, and all this without the least affectation of the blue stocking."

Susan Ferrier kept house for her father and enjoyed the civility of Edinburgh society. Henry Brougham is said to have been an "old school-fellow" and received her when he made a tour in Scotland as Lord Chancellor in 1834. Among other admirers were Joanna Baillie and Thomas Macaulay.

Around 1840, her eyesight failed and, increasingly, she had to pass most of her time in a darkened room, receiving a few friends at tea, but leading a very retired life.

Marriage. A Novel. Edinburgh: William Blackwood, Ltd.,
1818.

First edition in three volumes. Susan Ferrier wrote three novels, the
first two of which were published anonymously: *Marriage* (1818), *The
Inheritance* (1824), and *Destiny* (1831). Her work enjoyed great popu-
larity, offering keen observation on contemporary society with satiri-
cal and unsparing humor in the handling of all classes of her fellow
countrymen. The appreciation of her readers was no doubt quickened
by her portraits of known persons.

Scott noted in his diary that "Edgeworth, Ferrier, [and] Austen
have all given portraits of real society, far superior to anything man,
vain man, has produced of the like nature."

LENT BY THE COLEMAN PARSONS COLLECTION, THE RARE BOOK AND
MANUSCRIPT LIBRARY, COLUMBIA UNIVERSITY

Sir Walter Scott
(1771–1832)

Scott's achievement among men of letters is unique. Having estab-
lished his reputation as the most renowned British poet of his day–
Byron called him the monarch of Parnassus–he went on to carve out
an even more splendid career as a world-famous novelist. What really
set him apart was the rock-solid foundation of his literary and histori-
cal scholarship upon which all his work rests.

He was born in Edinburgh where his devout and austere father was
a Writer to the Signet; his mother, a well-educated woman, was also
devout but of a light and happy temper. After an infantile fever, Scott
lost the use of his right leg but grew to sturdy manhood and in spite of
a permanent deformity was capable of walking and riding great dis-
tances. He grew up hearing ballads and stories from his family and
was described by a childhood friend as "already an incomparable
story-teller." Scott attended the University of Edinburgh, leaving it to
be apprenticed to his father in the law. Legal work never distracted
him from his antiquarian researches or his gathering of materials on
traditional border ballads.

A man of great charm, Scott was beloved as a husband and father.
He thought little of regular educational systems but imparted to his
children his own love of poetry and history.

In 1820, George IV presented him with a baronetcy. Scott was ru-
ined in the great business crash of 1826 in which his publisher went

bankrupt. He assumed entire responsibility for the huge debt and began the gallant task of repaying his creditors in full from the earnings of his writing. A prolific writer, his relentless labor to repay his debts along with the deaths of his wife and his dearly loved little grandson hastened his own end.

His writings had an immeasurable influence on the Romantic movement at home and abroad.

Sir Walter Scott

Artist Unknown
Oil on canvas
Oval 50.3 x 41.7 cm. (19½ x 16½ in.)
A portrait of Scott probably between the ages of 10 and 12.

LENT BY THE GROLIER CLUB, NEW YORK

The Minstrelsy of the Scottish Border: Consisting of Historical and Romantic Ballads. . . . Kelso: Printed by James Ballantyne for T. Cadell, jun. and W. Davies, London, 1802.

Scott's collaboration with the scholar John Leyden, the antiquary Richard Heber, and the "Ettrick Shepherd" James Hogg, produced one of the finest collections of traditional border ballads in Scottish literature. The first edition, which is shown here, was published in two volumes in 1802 by Scott's old schoolmate John Ballantyne and sold out in three months. A third volume, which included some of Scott's own ballad imitations, appeared in 1803.

Despite the "composite" nature of many of the ballads, due to Scott's overzealous collating of variant texts, he rescued a waning oral tradition from certain oblivion. Scott's erudite preface and detailed footnotes in this work remain equally memorable contributions to the corpus of Scottish literary history. The magnitude of Scott's accomplishment is best appreciated by the fact that this collection represents almost one-quarter of the authentic old ballads known today, which total little more than 300.

PRIVATE COLLECTION

Scottish Highlands, Lochs, and Figures

Sir Edwin Landseer (1802–1873)
Watercolor, signed and dated 1824
33.4 x 48.9 cm. (13⅛ x 19¼ in.)

Inscribed on the verso in Landseer's hand: "Drawn by Edwin Landseer for Sir Walter Scott upon his visit in 1824." The painting was done at the time of Landseer's first visit to the Scottish Highlands, a subject to which he was to return throughout his career as an artist. The figures in the painting are most likely those of the artist himself and Scott.

PRIVATE COLLECTION

The Lord of the Isles. Edinburgh: Printed for Archibald Constable and Co., 1815.

First edition. Large paper edition of 50 copies. *The Lord of the Isles* focuses on Scotland's early history. The theme of the poem is the forging of a united Scotland, closing with the Battle of Bannockburn.

At the request of Scott's publisher, the renowned artist J.M.W. Turner (1775–1851) made an extensive tour of Scotland in 1831 to gather material to illustrate Scott's *Poetical Works*, *Lord of the Isles*, and the *Minstrelsy of the Scottish Border*. During his tour, Turner met with Scott at the author's baronial home of Abbotsford near Galashiels.

During a storm at Staffa, Turner made rough sketches from inside Fingal's Cave. The result was not only the dramatic title-page vignette shown in this India proof print, but also the great oil painting, *Staffa, Fingal's Cave*, which Turner exhibited in 1832 with an appropriate quotation from Canto IV of *Lord of the Isles*.

PRIVATE COLLECTION

Waverley; Or, 'Tis Sixty Years Since. Edinburgh: James Ballantyne and Co. for Archibald Constable and Co., Edinburgh and Longman, Hurst, Rees, Orme, and Brown, London, 1814.

First edition. *Waverley* was published anonymously because Scott was not sure of its success and did not want to risk tarnishing his poetic laurels by a failure. In contrast to the clanking horrors of the then popular Gothic romance, the reading public discovered in *Waverley* both memorably eccentric and psychologically convincing characters pursuing adventures in "real" historical backdrops. Set in the time of Bonnie Prince Charlie, *Waverley* marked the birth of the historical novel, and with its "delirious" reception the new literary form was firmly established (Royle). By the end of 1814, some 5,000 copies had been sold at a profit of over £2,000. "I have seldom felt more satisfac-

tion," declared Scott, "when, returning from a pleasant voyage, I found *Waverley* in the zenith of popularity, and public curiosity in full cry after the name of the author." Until the secret of Scott's authorship was made public in 1827, several of his successive novels were published with the title-page imprint "by the author of *Waverley*." These novels thus came to be known collectively as the "Waverley novels." In the 25 titles that followed, Scott's teeming imagination ranged through history with an accuracy and a depth of knowledge that justified his title as the "Wizard of the North."

PRIVATE COLLECTION

Sir Walter Scott, Bart.

Charles Turner (1773–1857) after Sir Henry Raeburn (1756–1823)
Mezzotint, 1810
33.2 x 37 cm. (21 x 14½ in.)

LENT BY THE YALE CENTER FOR BRITISH ART, THE PAUL MELLON FUND

Tales of a Grandfather. Edinburgh: Printed for Archibald Constable and Co., 1828.

First edition. Scott wrote this non-fictional history of Scotland up to the Jacobite uprising of 1745 for his grandson James, son of John Gibson Lockhart. In his journal, Scott noted his plans to fashion a narrative that would bridge "what a child can comprehend and what shall not be absolutely uninteresting to the grown reader." *Tales of a Grandfather* first appeared in two series between 1828 and 1829; a third series appeared in 1830, while the fourth series, published in 1831, presented a history of France.

PRIVATE COLLECTION

John Gibson Lockhart
(1794–1854)

The biographer and son-in-law of Sir Walter Scott was born at the manse of Cambusnethan into a minister's family. Before he had reached the age of 12, he had been enrolled at the University of Glasgow where his enthusiasm for Greek procured him a nomination to Balliol College, Oxford. From there, he went on to Edinburgh to study law. The continental travels of this brilliant Tory writer included a meeting with Goethe in Germany. In 1817, along with his fel-

low advocate John Wilson, Lockhart became a contributing editor to
the newly founded *Blackwood's Magazine*; together with James Hogg
they also published that year the scathing *Chaldee Manuscript.*

In 1825, on the advice of his father-in-law, Sir Walter Scott, Lock-
hart moved to London to assume the editorship of John Murray's
Quarterly Review. He held the position until 1853 when ill-health
forced him to retire. After a visit to Italy, he returned to Abbotsford,
which his daughter had inherited from Scott. He died there in the late
fall of 1854 and was buried at Dryburgh Abbey at the feet of Sir Walter
Scott.

Memoirs of the Life of Sir Walter Scott, Bart. Edinburgh: Robert Cadell, 1837–1838.

First edition in seven volumes. John Lockhart is usually remembered
as the notorious critic, essayist, and editor of *Blackwood's Magazine*
and the *Quarterly Review* who launched many savage attacks against
Leigh Hunt and the "Cockney" school of poetry, including a lacerat-
ing, satirical critique of John Keats' juvenile poem, *Endymion.* How-
ever, Lockhart redeemed his literary reputation largely through his
more judicious biographical works which included a brilliant *Life of
Burns*, and, more particularly, his monumental seven-volume biogra-
phy of Sir Walter Scott, whose daughter Sophia he had married in
1820. Although flawed by several errors, *Memoirs of the Life of Scott*
ranked in scale and importance second only to Boswell's *Life of John-
son* in the biographical literature of the time (Royle). Generously
Lockhart gave over all the profits of the biography to Sir Walter's
creditors.

PRIVATE COLLECTION

A View of Edinburgh from the West
Alexander Nasmyth
Oil on canvas, c. 1822–1826
61.5 x 92 cm. (24¼ x 36½ in.)

LENT BY THE YALE CENTER FOR BRITISH ART, THE PAUL MELLON
COLLECTION

The Edinburgh Review
History ascribes to Scotland the creation of the periodical review as
the authoritative medium for literary criticism in the 19th century.
Previously, what passed for independent commentary amounted to

little more than the self-aggrandizing endorsements of authors and publishers hawking their own books. Occasional reviews of a more objective tenor did surface in 18th-century newssheets but quickly faded from view when these publications failed. Following the success of *The Gentleman's Magazine* (founded 1731), periodical magazines began to appear on a regular basis but their focus was on publishing original works of prose and poetry rather than literary criticism.

The Edinburgh Review and Critical Journal was the first and most powerful of all the critical reviews. Founded by two Scottish lawyers, Francis Jeffrey and Henry Brougham, and an English doctor of divinity named Sydney Smith, the first issue appeared in 1802 and continued quarterly thereafter until 1929.

Jeffrey's chief accomplishment as editor was to gird *The Edinburgh Review* with an editorial point-of-view that was so focused that it bordered on partisanship. He distinguished *The Edinburgh Review* from the recent outcrop of magazines by limiting its scope to literary and political exegeses. Celebrity authors and "personalities," whom Jeffrey paid handsomely for contributions (up to £20 per sheet), invigorated the pages of *The Review* with personably stylish and occasionally controversial essays.

Under Jeffrey's careful stewardship, *The Review's* influence and stature grew exponentially throughout Great Britain. By 1818, *The Edinburgh Review* had acquired 14,000 subscribers, but the real extent of its reach is best measured by the staggering number of reprints it published in book form. The years 1814–1815, for example, saw the 10th and 7th editions of Volumes I and II, respectively, roll off the presses.

Despite its all-encompassing influence, *The Edinburgh Review* cannot be regarded as an accurate barometer of the literary trends of the day. Although none could qualify as literary scholars, Jeffrey and his cohorts nevertheless were intellectually vain enough to appoint themselves the literary mandarins of *taste*. Where *The Review's* political bent was emphatically liberal, its literary proclivities were, according to Jeffrey's charter editorial, ultra-conservative and resolutely biased in favor of "the loftiness of Milton and . . . the propriety of Pope." Thus, the editorial triumvirate in its heyday failed to recognize the far-reaching significance of the Romantics and consequently lambasted every major poet of the movement, from Southey to Wordsworth, Shelley, Coleridge and Byron–and even Scott, who had at one point been a key contributor to *The Review*. The only sense of judiciousness maintained by the editorial board was that it spared no one from its vituperations.

The Review engendered many successful imitators which likewise were founded by Scotsmen. The London-based *Quarterly Review* (est. 1809) modeled itself on *The Edinburgh Review's* format while the monthly *Blackwood's Magazine* (est. 1817) adopted its swaggering editorial style.

[Henry Brougham (1778–1868)]. *Review of Byron's 'Hours of Idleness'* (1807) in *The Edinburgh Review,* January 1808.

Brougham blasted Byron's first published book of poems in this article which appeared anonymously in *The Edinburgh Review.* Ever the barrister, Brougham framed the first portion of his critique as a courtroom argument and found the poorness of the verses indefensible on the grounds of Lord Byron's extreme youth (he was all of 18). Brougham then leveled ridicule at the "noble minor's" condescending attitude toward the writing profession. In his preface to *Hours of Idleness,* Byron had repeatedly referred to his noble Scottish ancestry and had used it as an inflated "plea of privilege"–which no doubt had irritated the solidly Whiggish Brougham. The criticism was so cutting that Byron retaliated one year later by lambasting the editorship of *The Review* in his brilliant satire, *English Bards and Scotch Reviewers.*

LENT BY THE PIERPONT MORGAN LIBRARY, NEW YORK

George Gordon Byron, Sixth Baron
(1788–1824)

English Bards and Scotch Reviewers. London: James Cawthorn, [1809].

First edition. In the 19th century there were no Scottish poets of major stature other than Scott, unless Lord Byron qualifies on a technicality of birth and on the basis of his mercurial temperament which had much in common with the "clear contrair" of the Scottish disposition. As he himself proudly declared in *Don Juan*, he was "half a Scot by birth and bred/A whole one. . . ." Born in London to "Mad Jack" Byron and Elizabeth Gordon, Byron spent his childhood in Scotland in and around Aberdeen with his mother, who was the last Laird of Gight. He attended the Aberdeen Grammar School and completed his education at Harrow and Trinity College, Cambridge.

When *The Edinburgh Review* pilloried his juvenile *Hours of Idle-*

ness, Byron responded in kind with his sardonic *English Bards and Scotch Reviewers*. The occasion was a felicitous one wherein Byron saw an opportunity to cut up both his critics and his rivals–which he did with great gusto.

In the passage displayed here from the text, Byron, thinking that Jeffrey–not Brougham–had penned the anonymous review, plays up all the allusions to Jeffrey's quondam profession as an advocate. Needless to say, *English Bards and Scotch Reviewers* was never reviewed in Jeffrey's journal.

LENT BY THE PIERPONT MORGAN LIBRARY, NEW YORK

James Hogg
(1770–1835)

The poet and novelist James Hogg was baptized at Ettrick, Selkirkshire, where his ancestors had been shepherds for generations. He began herding at the age of seven after less than a year's formal education. He later kept farms in Yarrow and Dumfriesshire. When the last of these pastoral enterprises failed in 1810, Hogg moved to Edinburgh to make a living as a writer.

A refreshing contrast to the urbane, studied manners of Edinburgh society, Hogg possessed an unvarnished rusticity and untutored clarity of vision that charmed the city's cultural elite. John Wilson immortalized Hogg in *The Noctes Ambrosianae* in *Blackwood's* (1822–1835) as the affable *Ettrick Shepherd*–a nickname associated with him ever since.

Hogg's natural gifts as a songwriter were first critically recognized with the publication of a collection of pastoral poems in 1801; Hogg's *Jacobite Relics* further enhanced his reputation in the area of Scottish song. However, the real turning point in his career came when he met Sir Walter Scott. The passion they shared for traditional Scottish ballads cemented their friendship. Hogg and his mother provided Scott with much of the original material that Scott published in *The Minstrelsy of the Scottish Border* (1802).

Kilmeny from *The Queen's Wake* (1813) in *The Poetical Works of James Hogg*. Edinburgh: Printed for Archibald Constable and Co., Edinburgh; and Hurst, Robinson & Co., London, 1822.

First collected edition in four volumes of Hogg's poetical works. *The Queen's Wake* established Hogg's reputation as a writer in Scotland and England. The work took its inspiration from Scott's historical verse poems that were then in vogue. Hogg adapted Scott's narrative style and offered several different poems which were recited by bards in a competition celebrating the arrival in Edinburgh of Mary Stuart as Queen of Scotland. In this work, Hogg disguised some of his contemporaries as 16th-century minstrels and himself as the "Bard of Ettrick." One of the most popular songs in *The Queen's Wake* is *Kilmeny*, a lay in antique Scots that tells the story of a virgin who is spirited away to heaven by fairies and given a troubling allegorical vision of the future reigns of Queen Mary and her son, James VI of Scotland and I of England.

PRIVATE COLLECTION

The Private Memoirs and Confessions of a Justified Sinner. London: Printed for Longman, Hurst, Rees, Orme, Brown, and Green, 1824.

First edition. Today, Hogg is best known for this macabre and complex novel of diabolical possession and theological satire. In it, Hogg views evil as arising from the distortion of theological doctrine through fanaticism. The religious zealot Robert Wringhim and his Mephisto-like mentor Gil-Martin embody the extremes to which Calvinist predestination can go—namely, that sins committed by the Elect may not be sins at all but part of God's higher plan. Its labyrinthine, subjective narrative explores the depths of madness and obsession.

Fearing the novel would be ill-received, Hogg published *Confessions* anonymously. Although he later published an abridged version, the complete novel was not printed again until 1895. Upon rediscovering the *Confessions* in the 20th century, André Gide wrote a critical reevaluation of the work in which he proclaimed it a masterpiece.

PRIVATE COLLECTION

John Galt
(1779–1839)

The son of an Ayshire sea captain, Galt left grammar school to be an apprentice clerk for a local merchant. Throughout his life, he was in-

volved in unsuccessful business ventures, the most ambitious of which took him to Canada as Secretary to the Canada Company. He founded the city of Guelph on the spot where he hewed down the first tree in what was then a wilderness. But he quarrelled with officials and returned to Scotland where he was briefly incarcerated in a debtor's prison.

His writing career was more successful than his business schemes. Galt still stands as one of the best novelists of the early 19th century, sensitive to the major social, political, and economic issues of his day, and a sympathetic interpreter of Scottish Calvinism.

Annals of the Parish. Printed for William Blackwood, Ltd., Edinburgh; and T. Cadell, London, 1821.

First edition. With the keen insight of a social historian, Galt examines the changes that had begun to alter the complexion of provincial Scottish life as he remembered it from his childhood in Greenock, a seaport west of Glasgow. Galt regarded his books as a series of "theoretical histories," unified not by conventional plot lines but more commonly strung together through the narrative of a single, sympathetic character.

His best-known novel, *Annals of the Parish*, draws upon his own childhood reminiscences and depicts life in the imaginary Ayrshire village of Dalmailing through the eyes of its elderly minister, Micah Balwhidder. Semi-autobiographical voices like Balwhidder's allowed Galt to exploit the warm, earthy resonance of various regional dialects which he believed best expressed the character and spirit of the Scottish people. The novel remains the most authentic and human picture of Scottish village life during the reign of George III.

PRIVATE COLLECTION

The Entail; Or, The Lairds of Grippy. Edinburgh: William Blackwood, Ltd. and London: T. Cadell, 1823.

First edition in three volumes, uncut and in original boards. *The Entail* completes the cycle of Scottish novels that Galt had begun in 1821 with *Blackwood's* serialization of *The Ayrshire Legatees* and *Annals of the Parish*. Chronicling the rise and fall of a self-made man and his family over a period of three generations, Galt examines the corruptibility of familial affections over money matters. He also details the sordid property disputes that avarice inspires among family members

after the death of the patriarch. Written at the peak of the author's brilliance, the book was read by Scott and Byron three times each. Galt's prophetic vision of the crassness of 19th-century materialism presaged the dark, cynical fiction of Balzac, Dickens, Hardy, Zola, and Galsworthy.

PRIVATE COLLECTION

Thomas Carlyle
(1795–1881)

Historian and essayist. Carlyle was born in a small village in Dumfriesshire where his father was a farmer. A stern, Scotch Calvinist, the father supplied Thomas' early education with a strong grounding in mathematics. Discerning the youth's intellectual ability, his father sent him to university to study for the ministry. (Accordingly, Thomas set off, walking to Edinburgh, 100 miles away.) Unable to accept various points of doctrine as required by the Church, Carlyle endeavored to be self-sufficient as a math tutor and began a long struggle against poverty, ill-health and depression. He met and married Jane Welsh (1801–1866), a woman of remarkable intelligence and spirit who at a young age insisted upon learning Latin, and attended Haddington school. The couple settled down to a spartan existence on the farm at Craigenputtoch which belonged to her family and where Carlyle honed his literary skills. In 1831, they moved to London and began a somewhat more convivial life. Carlyle gained a reputation and a small income through contributions to *The Edinburgh Review*. His great *History of the French Revolution* appeared in 1837, and in 1839 *Chartism* set forth Carlyle's unique principles which distinguished him equally from Whigs, Tories, and ordinary radicals, and expressed an extreme form of the discontent that had accumulated during the first quarter of the century against existing institutions. Carlyle was one of the few thinkers of the age to attempt an understanding of the problems created by the new industrial society. Among his friends were Goethe, J. S. Mill, and Emerson. Ruskin called him his "second earthly master" (J.M.W. Turner was Ruskin's first). Thomas, as the grand old man of British letters, had declined the honor of burial at Westminster Abbey. Instead the Carlyles were buried separately with their respective parents in Scotland.

Thomas Carlyle

Alphonse Legros (1834–1911)
Etching and India Ink
43.8 x 34 cm. (17¼ x 13⅜ in.)

Inaugural Address. Edinburgh: Edmonston & Douglas, 1866.

First edition representing the speech delivered by Carlyle when he was installed as Lord Rector of the University of Edinburgh in April 1866.

Sartor Resartus; the Life and Opinions of Herr Teufelsdröckh. London: Saunders and Otley, 1838.

First London edition. Presentation copy signed by the author to his wife Jane. A largely autobiographical work inspired by German novelist Johann Paul Friedrich Richter (1763–1825), *Sartor Resartus* (The Tailor Re-Patched) recounts the spiritual odyssey of the fictional German philosopher Diogenes Teufelsdröckh (Devil's Dung) from the Eternal NO of the universe to the Eternal YES.

After a satirical disquisition on clothes in Part I, Carlyle's alter ego, Teufelsdröckh, concludes that the organizing principles of society–like fashion–go in and out of style arbitrarily and therefore lack intrinsic merit. Part II is a thinly veiled account of a spiritual crisis Carlyle himself experienced but affirms the author's own conviction that the substantive values of life, which could counteract the soullessness of the industrial age, were anchored in the Calvinist ethic of pure, hard work and vigilant Christianity. Other autobiographical details abound, particularly of Carlyle's hometown of Ecclefechan (Entepfhul), and Edinburgh.

Sartor Resartus was first serialized for *Frazer's Magazine* of London in 1833–1834. The first edition in book form was printed in 1836 in America, followed by the first British edition in 1838.

Robert Louis Stevenson
(1850–1894)

Edinburgh: Picturesque Notes. With etchings by A. Brunet-Debaines from drawings by S. Bough, R.S.A. and W. E. Lockhart, R.S.A. and vignettes by Hector Chalmers and R. Kent Thomas. London: Seeley, Jackson, and Halliday, 1879.

First edition. In 1867, Stevenson entered the University of Edinburgh, where he began studying to become a lighthouse engineer, following in the family tradition. His interests in engineering, however, soon flagged, and he turned to law. Outside of his academic pursuits, much of his time was spent exploring his native city and cultivating a bohemian existence in the brothels and taverns of the Old Town and Leith Walk where he was known as the "Velvet Coat." The disquieting juxtaposition of the gritty, nocturnal underside of Edinburgh with the prevailing rigid propriety of its middle-class gave rise to Stevenson's ambivalence about his hometown, a feeling he expressed in *Edinburgh: Picturesque Notes.*

However uncongenial the biting winds and rigid the social conventions of Edinburgh were, the city remained ever near to Stevenson's thoughts. Years later, lying in the cockpit of the Casco in the South Pacific on his way to his new home in Samoa, Stevenson suddenly had a vision of Drummond Street: "When I remember all I had hoped and feared as I pickled about Rutherford's in the rain and the east wind; how I feared I should make a mere shipwreck, and yet timidly hoped not; how I feared I should never have a friend, far less a wife, and yet passionately hoped I might; how I hoped (if I did not take to drink) I should possibly write one little book, etc., etc. And then now—what a change! I feel somehow as if I should like the incident set upon a brass plate at the corner of that dreary thoroughfare for all students to read, poor devils, when their hearts are down. . . ."

PRIVATE COLLECTION

A Child's Garden of Verses. London: Longmans, Green, and Co., 1885.

First edition. Chronic weakness of the lungs and attendant suscepti-

bility to the raw damp of Edinburgh confined Stevenson to a sick bed for most of his boyhood under the devoted care of his nurse, Alison "Cummie" Cunningham, who fueled the boy's imaginative genius with tales of the Covenanters and stories from the Old Testament. G. K. Chesterton recalled in a 1901 article in *The Daily News* that Stevenson had composed the best part of *A Child's Garden of Verses* when he was "so heavily stricken with a deadly danger of the lungs that he had to lie in bed day and night, and was permitted neither to move nor to speak. On top of this his right arm was put into a sling to prevent hemorrhage. In addition because his eyesight was in danger, he had to lie in complete darkness. Out of that horrible darkness and silence and immobility comes a voice that says: 'The world is so full of a number of things, I'm sure we should all be as happy as kings.' To read of such a thing is like hearing a corpse speak suddenly of birds and sunshine." Stevenson dedicated this book to "Cummie," whom he called, "My second Mother, my first Wife." The tone of the collection is wholly personal, modulated by its intensely lyrical and sensitive rendering of childhood daydreams, games, and pastimes.

PRIVATE COLLECTION

Treasure Island. London, Paris, & New York: Cassell & Company, Limited, 1883.

First edition. In an article from the August 1894 issue of *The Idler* magazine, Stevenson recounts how his literary blueprint for *Treasure Island* took shape from an imaginary map he had made while painting pictures one rainy afternoon with his stepson Lloyd Osbourne. The book's briskly paced adventure, involving cutthroat pirates and hidden treasure, is set in the 18th century against the exotic backdrop of distant South Sea islands–all of which on the surface make *Treasure Island* a "rattling good read" for both children and adults. The novel was first published serially in *Young Folks' Magazine* under Stevenson's pseudonym, "Capt. Geo. North."

Yet Stevenson's yarns are not historical novels like those of Scott or Galt, who pointedly used the genre for comparisons between "now" and "then." His consummate skill as a fiction writer and ability to sustain adult interest lay beyond his taut storylines and the rich, palpable atmospherics of his historical settings. Rather, it is the complex, psychological mold of his characters that allows Stevenson to comment on the tense duality between good and evil in human nature and to ex-

plore the moral ambiguity rooted in human actions. Confrontation with multifarious and flawed characters such as Long John often engages Stevenson's adolescent heroes in a fierce inner struggle with their own Kirk-bred consciences. Their adventures off the beaten track of respectability and their resolve to accept the consequences of their actions characteristically mark their well-earned passage into adulthood.

PRIVATE COLLECTION

The Strange Case of Dr. Jekyll and Mr. Hyde. London: Longmans, Green, 1886.

First edition. Dr. Henry Jekyll, the central character in this most famous of Stevenson's novels, concocts a drug that will separate the dual aspects of good and evil in his personality. The evil manifestation, the hideous and brutish Edward Hyde, gradually becomes the dominant figure and begins to commit a number of crimes, including murder. Unable to find an antidote that will suppress Hyde and unable to bear the shame of public exposure, Jekyll takes his own life.

The theme of the divided personality had preoccupied Stevenson as early as 1878, when he collaborated with W. E. Huntly on a play about the illicit adventures of one Deacon Brodie of Edinburgh. Brodie was a robber and rake by night and an industrious carpenter and model citizen by day. He was hanged at Tolbooth prison on a gibbet of his own devising. What is so Scottish about this novel, despite its London locus, is the view maintained by both church and society that human nature is made up of moral absolutes and must answer to an ethical order built upon the same principle of extremes. Through the tormented Dr. Jekyll, Stevenson effectively opposed that attitude by showing the indistinct proximity of good and evil within even the most morally upright of men.

LENT BY THE THOMAS COOPER LIBRARY, UNIVERSITY OF SOUTH CAROLINA

Father Damien: An Open Letter to the Reverend Dr. Hyde of Honolulu From Robert Louis Stevenson. Sydney, 1890. Privately Printed.

This first edition is believed to have consisted of 25 copies privately issued by the author and bearing corrections in his own hand.

Increasingly frequent and dangerous episodes of tuberculosis de-

termined Stevenson to find a more hospitable clime in which to live. In 1888, he and his family set sail on a tour of the South Pacific and settled on the island of Upolu in Samoa, which would be home to Stevenson until his death in 1894.

Stevenson demonstrated a profound, sympathetic understanding of the culture and the peoples of his adopted region in *Father Damien*, which is a passionate defense of the Catholic missionary who died in 1889 serving the lepers of Molokai. Father Damien's efforts had been much maligned by the Reverend Dr. Hyde.

PRIVATE COLLECTION

Queen Victoria
(1819–1901)

Leaves from the Journal of Our Life in the Highlands From 1848 to 1861. . . . London: Smith, Elder and Co., 1868.

Presentation copy inscribed, "To Miss Murray MacGregor. In recollection of Blair-Dunkeld and Balmoral from Victoria Reg. June 9, 1868." This first edition of excerpts from Victoria's personal journals chronicles her Scottish sojourns with the Prince Consort from the couple's first visit to Balmoral in 1848 until Albert's death in 1861. Victoria's lively travelogue of her Highland family holidays at Balmoral are brimful of the picturesque charm that inspired a vogue in Victorian England for what poet and literary historian Roderick Watson has trippingly called "tourism, tartan, and turrets."

PRIVATE COLLECTION

Sir James M. Barrie
(1860–1937)

James Matthew Barrie was the son of a handloom weaver and a stonemason's daughter. He graduated from Edinburgh University and began a successful career as a journalist. Much of his early work appears under the name Gavin Ogilvie in *The British Weekly*.

He moved on to a series of stories and novels which were set in an imaginary village called Thrums and based on his own hometown in Kirriemuir. These sentimental, nostalgic sketches of village life and its

local inhabitants are emblematic of a literary cadre known as the Kail-yard School that surfaced in the 1890s. The term comes from the verse epigraph by Ian Maclaren, a literary contemporary of Barrie:

> *There grows a bonnie briar bush in our kail-yard, [cabbage-patch]*
> *And white are the blossoms on't in our kail-yard.*

Early in his career Barrie moved to London where his writing for the stage established him on both sides of the Atlantic.

Barrie's best work is now overshadowed by his tendency towards sentimental excess. Even in his day there was reaction to this, voiced best by the notable critic George Jean Nathan, who wrote that Barrie's work represented "the triumph of sugar over diabetes."

Peter Pan, 1903– 1904.

Autograph manuscript in ink with holograph corrections, substantially differing from the printed version. Inscribed by Barrie "To Maude Adams. This, the M.S. of *Peter Pan*, from her humble servant and affectionate friend. J. M. Barrie."

Barrie alone was supremely confident from the beginning about the worth of this play. Charles Frohman, the American impresario who was Barrie's great friend and his producer, wanted to defer the production because he felt it was sure to fail.

"To die," said Peter Pan, "will be an awfully big adventure." This line had a more dramatic rendering off-stage, for these were Frohman's last words as he stood on the deck of the sinking Lusitania.

LENT BY THE LILLY LIBRARY, INDIANA UNIVERSITY, BLOOMINGTON

Courage. London: Hodder and Stoughton Ltd., [1922].

The first edition of the Rectorial Address delivered by Barrie at St. Andrews University in 1922.

This copy is open to the end of his speech where he points out quite rightly that the great, ancient Scottish universities–St. Andrews, Aberdeen, Glasgow, and Edinburgh–are "not four, but five. The greatest of them is the poor, proud homes you come out of, which said so long ago: 'There shall be education in this land.'"

In addition to the Lord Rectorate at St. Andrews, Barrie was awarded the Order of Merit in 1922, appointed Chancellor of Edinburgh University in 1930, and was created a baronet.

PRIVATE COLLECTIONS

Auld Licht Idylls. London: Hodder and Stoughton, 1895.

First large paper edition of Barrie's first book with William Hole's illustrations which initially appeared in 1888.

Barrie writes with an affectionate and honest eye about the life of a small village in Northeast Scotland. It is considered one of his best works. Based on tales from his mother's memories, it recalls her growing up among the fiercely Presbyterian sect known as Auld Lichts.

Auld Licht Idylls and his memoir of his mother, *Margaret Ogilvie*, exemplify the emotional frankness with which Barrie could always write but never speak and which set him apart as one of the great originals.

PRIVATE COLLECTION

George Macdonald
(1824–1905)

The novelist and poet was born on an Aberdeenshire farm and educated at King's College, Aberdeen. He became a Congregationalist minister but failing health and a conflict of doctrinal views with his superiors forced him to resign, and he struggled to support his family of 11 children by writing and lecturing.

Macdonald is best known for his books of fantasy. He was a man of deep faith in a loving and gracious God, and his strong reaction against the strict tenets of orthodox Presbyterianism found expression in his earliest published works of poetry and in the novels *Phantastes* (1858) and *Lilith* (1895). These works suggest the possibilities of escape to other mystical and fairy worlds and they influenced Tolkien, Auden, Chesterton, and C. S. Lewis. No less important are his fairy tales for children, *At the Back of the North Wind* (1871), *The Princess and the Goblin* (1872), and *The Princess and Curdie* (1888). Macdonald wrote a series of Scottish novels, *David Elginbrod* (1863), *Alec Forbes* (1865), and *Robert Falconer* (1868), that show the author's ability to draw characters and to realize accurate regional dialect. His focus on the Scottish village and his sentimental treatment of the peasantry mark Macdonald as a founder of the Kailyard School.

Good Words for the Young. 1869 [1870, 1871, 1872]. Edited by Norman MacLeod, D.D. [other three volumes edited by George MacDonald]. London: Strahan & Co., 1869, 1870, 1871, 1872.

A monthly magazine for children. Each volume here is bound as an annual collection and features the first appearance of four of George Macdonald's full-length tales for children: *At the Back of the North Wind, Ranald Bannerman's Boyhood, The Princess and the Goblin*, and *The History of Gutta Percha Willie*. All were subsequently published in book form. The stories are profusely (and mystically) illustrated by Arthur Hughes. Additionally, these volumes include a short story and three poems by Macdonald.

PRIVATE COLLECTION

Phantastes: a Faerie Romance for Men and Women. London: Smith, Elder and Co., 1858.

First edition. This allegorical fantasy for adults creates a dreamworld of powerful effect and vivid strangeness.

LENT BY THE LILLY LIBRARY, INDIANA UNIVERSITY, BLOOMINGTON

George Douglas
[George Douglas Brown] (1869–1902)

George Douglas was the son of an Ayrshire farmer. Educated at Glasgow University and Balliol College, Oxford, he began his writing career in London with magazine and boys' fiction. He died suddenly at the age of 33, just after the publication of his great work, *The House with the Green Shutters*.

The House with the Green Shutters. London: J. MacQueen, 1901.

First edition. An acclaimed masterpiece of social realism, Douglas' novel joined with the work of John Davidson in sounding the angry and ugly tone of the modern age. The novel is set in a Scottish village where a grim view of human nature prevails.

LENT BY THE COLEMAN PARSONS COLLECTION, THE RARE BOOK AND MANUSCRIPT LIBRARY, COLUMBIA UNIVERSITY

John Davidson
(1857–1909)

Fleet Street and other Poems. London: Grant Richards, 1909.

First edition. The son of an evangelical minister, Davidson was brought up in Glasgow and Greenock. During his erratic, early teaching years, he met John Nichol, a professor of English at Glasgow University and a friend of Swinburne. Swinburne stoked Davidson's literary ambitions when he admired Davidson's early verses.

He contributed lyrics to the *Yellow Book*, mixed with the Rhymers' Club, and made friends with Max Beerbohm, Richard Le Gallienne, and Edmund Gosse.

T. S. Eliot admitted to being influenced by the poem, *30 Bob a Week*, and the poet's eye for "dingy urban images." Davidson was one of the first "angry young men" of his generation to portray the squalor, despair, and grim beauty of the modern city. *30 Bob a Week* is animated by a ferocious spirit raging at the material difficulties of making ends meet on a pittance.

Poverty, illness, and literary rejection dogged Davidson throughout his life and increasingly isolated him from friends and family. In 1907 he moved to Penzance, Cornwall, where he committed suicide in 1909, throwing himself from the cliffs into the sea. A day or two later, the manuscript of this volume was received by his publisher. With it was a suicide note, used here as a preface.

PRIVATE COLLECTION

John Buchan, First Baron Tweedsmuir
(1875–1940)

Buchan's father was a minister and Buchan grew up "in the grey manse on the Fife coast." One of the most delightful of literary companions, John Buchan was the consummate Anglo-Scot and was a graduate of Brasenose College, Oxford. He enjoyed great success on both sides of the border as a barrister and distinguished himself in literature as an essayist, war historian, biographer and, most notably, a novelist. A member of Parliament for the Scottish universities since

1927, he was appointed Governor General of Canada in 1935 and raised to the peerage.

The Thirty-Nine Steps. Edinburgh and London: William Blackwood and Sons, 1915.

The first edition of this crack mystery adventure, which remains Buchan's best-known book. His hero, Richard Hannay, continued his adventures in future novels and was handsomely portrayed by Robert Donat in Hitchcock's famous film adaptation of the book.

PRIVATE COLLECTION

Memory Hold-the-Door. London: Hodder and Stoughton, Ltd., 1940.

Buchan completed his autobiography shortly before his death, and the first edition of the work was published posthumously.

PRIVATE COLLECTION

Hugh Mac Diarmid
[Charles Murray Grieve] (1892–1978)

Born Charles Murray Grieve in Langholm in the Border Country, Hugh MacDiarmid is the commanding spirit behind this century's dominant literary movement known as the Scottish Renaissance. A post-World War I movement born of patriotic reaction, the Scottish Renaissance took MacDiarmid's motto "Back to Dunbar" (referring to the great 15th-century poet of the vernacular, William Dunbar) as its credo.

MacDiarmid's early career was in journalism. An energetic literary figure, he emerged suddenly as a major poet with the publication of three important books: *Sangschaw* (1925), *Penny Wheep* (1926), and *A Drunk Man Looks at the Thistle* (1926). These poems, written in vigorous Scots and treating the contemporary Scottish scene, had an electrifying effect and restored *Lallans* as a poetic tongue. Originally, *Lallans* was the name given to the historic speech of Lowland Scotland but since about 1946 it has been applied specifically to the language developed by MacDiarmid and others to recreate and extend the range and vocabulary of Scots dialect in literary usage. This involved the mixing of words from different geographic areas and ages.

Detractors argued that this was "synthetic" or "plastic" Scots based on archaic words found only in dictionaries and no longer in common currency.

MacDiarmid's literary success was accompanied by financial failure. He lived for years in destitution, sometimes sailing out of Shetland with the Merchant Navy. Bitterness of spirit and poetic idealism led him to join the Communist Party.

Sangschaw. Edinburgh and London: William Blackwood and Sons Ltd., 1925.

A dedication copy of the first edition of MacDiarmid's first book of poetry, inscribed by the author to his mother.

In the preface to *Sangschaw*, John Buchan remarks that the boldness of MacDiarmid's purpose is "to treat Scots as a living language and apply it to matters which have been foreign to it since the sixteenth century."

LENT BY DUVAL & HAMILTON

Penny Wheep. Edinburgh and London: William Blackwood and Sons Ltd., 1926.

First edition of the second volume of poetry, dedicated to the poet's wife.

PRIVATE COLLECTION

A Drunk Man Looks at the Thistle. Edinburgh and London: William Blackwood and Sons Ltd., 1926.

First edition. Dedication copy, inscribed to Francis George Scott. Scott was a composer who became good friends with MacDiarmid and who set many of the poet's works to music. Scott's musical influence is especially felt throughout the single poem which comprises this book. A drunk man is found lying in the moonlight in front of a huge thistle which seems to be in a constant state of metamorphosis. MacDiarmid uses the drunk man's struggle to perceive the true nature of the thistle as a starting point to investigate the divided nature both of Scotland and of all mankind. A hugely ambitious work, this poem is considered to be the finest sustained work in Scots written during this century, and, by any standards, a major work of art.

LENT BY DUVAL & HAMILTON

Direadh I, II, and III. Frenich Foss [Scotland]: Kulgin Du-
val & Colin H. Hamilton, 1974.

One of 200 numbered copies signed by the author. Designed by Mar-
tino Mardersteig and printed in Dante type on Magnani paper at the
Stamperia Valdonega in Verona.

Direadh means *act of surmounting*, and the poet explains that these
poems express his endeavor to see Scotland whole. MacDiarmid's ver-
bal exuberance sometimes recalls that of the 17th-century writer, Sir
Thomas Urquhart.

PRIVATE COLLECTION

Edwin Muir
(1887–1959)

Born on a farm in Orkney, Muir received his education on the islands
before moving to Glasgow where he worked as a clerk during the De-
pression. He moved on to London where he began writing. T. S. Eliot
believed his criticism to be the best of our time. Hugh MacDiarmid
recognized him as a key man in the Scottish Renaissance movement,
one who had "become a conscious Scot."

Muir used Lallans for some early ballad work but the great body of
his work is in English. His writing examines essential concerns of
modern society: the effect of unemployment on the human spirit, the
tyranny of right and left, and the threat of nuclear war.

As a young man, he was an ardent Socialist; in time he came to syn-
thesize the doctrines of his religious faith with the political and social
elements of his artistic vision.

He was the British council representative in Prague at the close of
World War II and among his greatest achievements are his transla-
tions of Franz Kafka. In 1954, he was appointed the Charles Eliot
Norton Professor at Harvard.

Scottish Journey. London: William Heinemann, Ltd., in association with Victor Golancz, Ltd., [1935].

First edition. Presentation copy in dust jacket, inscribed "With love,
Edwin." Far from the pleasant tour suggested by the title, this is Scot-
land seen by a young man sensitive to all the social and spiritual ills
around him.

The poem displayed here in its first printing was later titled "Scot-

land's Winter" and was next published in *One Foot in Eden* (1956). Muir's imagination raises this poem far above the level of propaganda.

PRIVATE COLLECTION

One Foot in Eden. London: Faber and Faber, [1956].

This volume of poems is the product of Muir's mature vision, and particular topics have taken on a more universal significance. This is considered by many to be his best poetry.

PRIVATE COLLECTION

Neil M. Gunn
(1891–1973)

The son of a fisherman, Gunn was born in Dunbeath on the Caithness coast, which he later used as the setting for his best books, including *Morning Tide*. He attended the village school until he was 12. Appointed an officer in the Customs and Excise Service in 1911, he worked as a distillery officer at Inverness.

His friendship with Hugh MacDiarmid led Gunn to write short stories for *The Northern Review*. His first novel, *The Grey Coast*, which was based on his knowledge of the fishing villages of Northeast Scotland, was published in 1926. In the 1930s Gunn turned less successfully to writing plays for the theatre. After his second novel, *The Lost Glen*, had been serialized in the *Scots Magazine* in 1928, he published *Morning Tide*, his first financially successful novel.

Gunn became involved in the politics of the Scottish National Party to the point where he resigned from the Customs and Excise in 1937 to devote his complete attention to writing. Between 1938 and 1949, Gunn's writing career was at its most productive: He wrote 11 novels, including *The Silver Darlings* (1941). Gunn is heralded as the most important prose writer of the Scottish Renaissance Movement.

His later years were spent at Kincraig, Kerrow in Glen Cannich, and Dalcraig on the Black Isle near Inverness. His last novels included *The Well at the World's End* (1951), *Bloodhunt* (1952), and *The Other Landscape* (1954). Gunn also produced several collections of short stories including *The White Hour* (1950) and *The Atom of Delight* (1956), which was an autobiographical work that focused on his fascination with Zen Buddhism. He also wrote radio and documentary film scripts.

Morning Tide. Edinburgh: The Porpoise Press, 1931.

First edition in original dust jacket. Although Gunn's plots and characters are structured after the traditional novel, all his works evoke an everyday reality with a rich subtext of symbolic significance. In *Morning Tide*, Gunn draws upon his childhood memories of his native fishing village and his impressions of the vast ocean. In Hugh Mac-Beth, his autobiographical hero, Gunn superbly captures the inner tensions of a boy coming of age by dramatizing the adolescent's life and death struggles with the sea.

PRIVATE COLLECTION

Lewis Grassic Gibbon
[James Leslie Mitchell] (1901–1935)

Lewis Grassic Gibbon was born James Leslie Mitchell on his father's farm in Aberdeenshire. He was educated locally before going to Glasgow to work as a journalist. Army service provided him with the opportunity to travel, which resulted in various writings under his own name.

A Scots Quair: Sunset Song, Cloud Howe, Grey Granite

Gibbon is remembered for his trilogy of previously published novels which were then issued in 1946 under the collective title of *A Scots Quair*. Unmistakenly of the modern age, Grassic Gibbon writes a strong narrative about the red clay country of the Mearns and of its inhabitants whom he knew so well. Shown here are the first published editions of each novel in the trilogy: *Sunset Song* (London: Jarrolds, 1932), *Cloud Howe* (London: Jarrolds, 1933), and *Grey Granite* (London: Jarrolds, 1934).

The trilogy recounts the life of a young woman, Chris Guthrie, from her girlhood on a poor Aberdeenshire farm through womanhood against the background of World War I and the Depression. These novels portray a bleak realism which does not draw back from depictions of sexuality and violence. Many readers at the time objected to the rawness and frank tone of the works.

LENT BY THE LILLY LIBRARY, INDIANA UNIVERSITY, BLOOMINGTON

Fionn MacColla
[Thomas MacDonald] (1906–1975)

Fionn MacColla was a great lover of the *Gàidhealtachd*, or the world of the Gael. He was born in Montrose of a Plymouth Brethren family. Educated in Aberdeen, he became headmaster of a school where he defied official educational policy by encouraging the use of Gaelic among his pupils.

"'A house divided against itself cannot stand'–and that house is Scotland" ought to be the motto for this author's entire work. In his autobiographical essay, "Mein Bumpf," MacColla writes: "To kill a culture is to knock the Creator out of his universe . . . to deface the Infinite–and when the culture is of so unique an idiosyncracy and enchantment as Gaelic culture, the offense is an act of unparalleled barbarism."

As a major writer of the Scottish Renaissance, MacColla argues for Scottish autonomy and unity which he felt would come through the use of the three tongues of Scotland: Gaelic, Scots dialect, and English. He is indeed unique in his use of a hybrid language–a trilingualism which he uses to great effect in his writings.

And the Cock Crew. Glasgow: William Maclellan, [1945].

First edition. Impassioned by the loss of the Gaelic culture in Scotland, MacColla tells the story of the Highland Clearances with great power and dramatic vision. This harrowing saga of the forced removal of people to make room for sheep herding (which was seen to be of greater economic value) is a perfect vehicle for the author to express his belief about the truths and values of the Gaelic worlds and the destruction of that world at the hands of culturally insensitive bureaucrats in government, or worse, at the hands of the local aristocracy.

LENT BY THE BOSTON PUBLIC LIBRARY

Sorley MacLean
[Somhairle MacGill-Eain] (b. 1911)

In MacLean's own words, he was "born in Raasay of a family of tradition-bearers, monoglot Gaelic speakers." He did not speak English

until he went to school. He taught in Skye, Mull, Edinburgh, and Plockton, and assisted teachers who were trying to preserve Gaelic in secondary schools.

As did so many artists at the time, MacLean called himself a Bolshevik–proving that a great poetic vision is not a guarantee of political acuity.

Dàin do Eimhir agus Dàin Eile. Glasgow: William Maclellan, 1943.

These poems to Eimhir were written in the 1930s. As Iain Crichton Smith has pointed out, these well-known poems of "a major poet writing in a minority language" are only a part of the greater corpus of his poetry.

The second poem shown here builds on the double meaning in Gaelic of the word *ciall* which can either mean "love" or "wisdom."

Iain Crichton Smith
(b. 1928)

Iain Crichton Smith was brought up in a Gaelic-speaking community in the outer Hebrides. He took his degree in English at Aberdeen University and was for many years a schoolmaster. He is now retired in Argyll where he continues to write.

His is a compassionate voice, deeply inspired by the natural setting of the Western Isles which speak of the isolation of the individual. Although he has written extensively in Gaelic and English, most of his published work is in English. A versatile and prolific writer of the first rank, he has produced poetry, novels, short stories, radio and television works, and literary criticism.

Poems to Eimhir: Sorley MacLean's Poems from Dain do Eimhir, translated from the Gaelic by Iain Crichton Smith. London: Victor Gollancz, Ltd., 1971.

First edition. In the preface of this highly praised translation of MacLean's famous poems, Smith declares that they rank among "the most original . . . we have had in Gaelic in this century." Original in style and revolutionary in content, the poems deal in part with political commitment, the demands on the artist during the Spanish Civil

War, and the conflict within the poet's personal life. Smith rightly states that MacLean should be judged above all as a love poet: these poems are united and charged with the passion of an actual love affair which confronted the poet with difficult choices in a harsh world.

PRIVATE COLLECTION

Love Poems and Elegies. London: Victor Gollancz, Ltd., 1972.

Review copy of the first edition. This collection of poems is presented in two parts. Part I deals with the death of the poet's mother while those in Part II constitute a series of love poems.

PRIVATE COLLECTION

George Mackay Brown
(b. 1921)

George Mackay Brown was born to a seamstress and a postman of a family who had lived in Orkney for 400 years. Mackay Brown has chosen to live all his life there except for two periods of study: the first was spent at Newbattle Abbey College where his fellow Orkneyman, Edwin Muir, was warden, and the second was at Edinburgh University where he took an honors degree in English.

Stromness, the "Hamnavoe" of his poems and stories, is both home and inspiration. Seamus Heaney, the poet, has written of Mackay Brown: "He transforms everything by passing it through the eye of the needle of Orkney." Unlike Muir, Mackay Brown has remained in this northernmost "Eden." But if his space is narrow, his range in time is wide: "Brown uses the technique of weaving together past and present, the mythical with the contemporary" (Royle).

As a young man, Mackay Brown spent time in hospital suffering from tuberculosis. A concern with death and resurrection and with faith and its renewal are themes central to his poetry. A religious perspective has a unifying effect on his work. In 1961, Mackay Brown converted to Roman Catholicism.

Mackay Brown is very conscious of being part of a tradition built on Norse sagas, oral tales, and Scots ballads. His is the art of the storyteller. With his bardic style and spare economy of words, he is the "singer of epic song" in the modern era, bridging old and new oral traditions.

The Year of the Whale. London: Chatto and Windus, The Hogarth Press, 1965.

The first edition of the poet's third book of poems. Maurice Wiggin notes that "his language is glorious. All the folk of the community are gathered up in his poetry, whether the twelfth century Earl Magnus, the Grey Monks of Eynehallow or the fisherman on the timeless sea."

PRIVATE COLLECTION

Stone. Verona: Officina Bodoni, 1987.

One of 125 copies printed on the handpress at the Officina Bodoni by Gabriella and Martino Mardersteig. Photographs reproduced by the Stamperia Valdonega; signed by the poet George Mackay Brown and the photographer Gunnie Moberg.

A masterful simplicity of word and image come together in this book. Some of the poems are considered by the author to be his finest work.

PRIVATE COLLECTION

A Time to Keep and Other Stories. London: The Hogarth Press, 1969.

First edition. Arguably George Mackay Brown's best, really magical, collection of short stories.

LENT BY THE LILLY LIBRARY, INDIANA UNIVERSITY, BLOOMINGTON

William Laughton Lorimer
(1885–1967)

The New Testament in Scots. Edinburgh: Published for the Trustees of the W. L. Lorimer Memorial Trust Fund by Southside Ltd., 1983.

Born near Dundee, Lorimer was educated there and at Trinity College, Oxford. He taught Latin and Greek and earned the reputation as one of the most distinguished classical scholars of his generation. Lorimer began studying spoken Scots as a child and became interested in the problems encountered by linguistic minorities in reviving or developing their languages. He became convinced that if Scots was ever to be resuscitated, two great works must be produced: a good

modern Scots dictionary and a good modern Scots translation of the New Testament.

Accordingly, during his retirement, he made substantial contributions to *The Scottish National Dictionary* and translated the New Testament from Greek into Scots. In doing so, he set out to recreate Scots prose, very little of which had been published since the late 16th century. Lorimer died before he could finish his revision, but the work was completed by his son. As a fitting tribute to his scholarship and to the vitality of the Scots language, Lorimer's *New Testament in Scots* was, upon publication, enthusiasically received by the reading public and has become a bestseller.

PRIVATE COLLECTION

BIBLIOGRAPHY

Aldis, Harry G. *A List of Books Printed in Scotland before 1700.* Edinburgh: National Library of Scotland, 1970.

Balding, R. & J. *The Scottish Enlightenment.* Catalogue 63. Edinburgh: R. & J. Balding, 1979.

Bell, Robin, ed. *The Best of Scottish Poetry: An Anthology of Modern Scottish Verse.* Edinburgh: W. & R. Chambers, 1989.

Blake, George. *Barrie and the Kailyard School.* New York: Roy Publishers, [1970].

Bold, Alan. *Modern Scottish Literature.* London & New York: Longman, 1983.

———. *Scotland: A Literary Guide.* London: Routledge, 1989.

Boswell, James. *Boswell's Journal of a Tour to the Hebrides with Samuel Johnson, LL.D., 1773.* Edited from the original manuscript by Frederick A. Pottle and Charles H. Bennett. New York: McGraw-Hill, 1961.

———. *Boswell's London Journal 1762–1763.* Prepared from the original manuscript by Frederick A. Pottle. The Yale Editions of the Private Papers of James Boswell. New York: McGraw-Hill, 1950.

Bower, Walter. *Scotichronicon by Walter Bower.* Edited by D.E.R. Watt. Vol. 8. Aberdeen: Aberdeen University Press, 1987.

Buchan, John. *The Kirk in Scotland.* Reprint. Dunbar: Laborum Publications, 1985.

Cassell's Encyclopaedia of World Literature. Revised ed. London: Cassell & Co., 1973.

Cherry, Alistair. *Princes, Poets and Patrons.* Edinburgh: HMSO, 1987.

Couper, W. J., ed. *Watson's Preface to the 'History of Printing'.* Edinburgh: The Darien Press, 1913.

Dictionary of National Biography. 63 vols. New York: Macmillan, 1885–1900.

Drabble, Margaret, ed. *The Oxford Companion to Englsih Literature.* 5th ed. Oxford: Oxford University Press, 1985.

Duval, K. D. *A Catalogue of Eighteenth Century Books.* Fife, Scotland: K. D. Duval, Autumn 1964.

_____. *Scotland in the Eighteenth Century*. Falkland, Scotland: K. D. Duval, Winter 1969.

Duval, K. D. and Colin Hamilton. *Scott and His Scotland*. Scotland: Duval & Hamilton, 1971.

Egerer, J. W. *A Bibliography of Robert Burns*. Edinburgh & London: Oliver & Boyd, 1964.

Encyclopædia Britannica. 11th ed. New York: The Encyclopædia Britannica, 1910–1911.

Erickson, Carolly. *Bonnie Prince Charlie*. New York: William Morrow & Co., 1989.

Fergus, David. "Stevenson in the Foot-Haunted City in the Night," in *The Scottish Book Collector*, vol. 2, no. 10 (April–May 1991), pp. 5–7.

Fraser, Antonia. *Mary Queen of Scots*. New York: Delacorte Press, 1970.

Gifford, Douglas. *Neil M. Gunn & Lewis Grassic Gibbon*. Edinburgh: Oliver & Boyd, 1983.

Gillie, Christophe. *A Companion to British Literature*. Detroit: Grand Rapids Books, 1977.

Glen, Duncan. *Hugh MacDiarmid and the Scottish Renaissance*. Edinburgh: W. & R. Chambers, [1964].

Hamilton, Colin and Joel Silver. *Scotland before the Union*. Exhibition catalogue. Bloomington, IN: The Lilly Library, Indiana University, 1985.

Hammerton, J. A., ed. *Stevensoniana*. Edinburgh: John Grant, 1910.

Henderson, T. F. *Scottish Vernacular Literature*. 3d ed., revised. Detroit: Gale Research Co., 1969.

Hewitt, David and Michael Spiller, eds. *Literature of the North*. Aberdeen: Aberdeen University Press, 1983.

Johnson, Edgar. *Sir Walter Scott in the Fales Library*. New York: New York University Libraries, 1968.

King, Charles, ed. *Twelve Modern Scottish Poets*. London: University of London Press, Ltd., 1971.

Lindsay, Maurice. *The Burns Encyclopedia*. New York: St. Martin's Press, 1980.

———. *History of Scottish Literature.* London: Hale, 1977.

Lockhart, J. G. *Life of Robert Burns.* Edinburgh: Constable, 1828.

Mackenzie, Henry. *The Anecdotes and Egotisms of Henry Mackenzie, 1745–1831, Now First Published.* Edited and with introduction by Harold William Thompson. London: Oxford University Press, 1927.

Maclean, Donald. *The Literature of the Scottish Gael.* Edinburgh & London: W. Hodge, 1912.

MacQueen, John. *Progress and Poetry: The Enlightenment and Scottish Literature.* Edinburgh: Scottish Academic Press, 1982.

McClure, J. Derrick. *Scotland and the Lowland Tongue: Studies in the Language and Literature of Lowland Scotland.* Aberdeen: Aberdeen University Press, 1983.

The National Library of Scotland. *The Eye of the Mind: The Scot and His Books.* Edinburgh: The National Library of Scotland, 1983.

Roy, G. Ross, ed. *Studies in Scottish Literature.* Vol. 25. Columbia, SC: University of South Carolina, 1990.

Royle, Trevor. *Companion to Scottish Literature.* Detroit: Gale Research Co., 1983.

Scheps, Walter and J. Anna Looney. *Middle Scots Poets: A Reference Guide to James I of Scotland, Robert Henryson, William Dunbar, and Gavin Douglas.* Boston: G. K. Hall, 1986.

Simpson, Kenneth. *The Protean Scot: The Crisis of Identity in Eighteenth Century Scottish Literature.* Aberdeen: Aberdeen University Press, 1988.

Smith, G. Gregory. *Scottish Literature: Character and Influence.* London: Macmillan, 1919.

Snyder, Franklyn Bliss. *The Life of Robert Burns.* New York: Macmillan, 1932.

Stevenson, James A.C. *Barbour's Bruce.* Vol 2. Edinburgh: Scottish Text Society, 1980.

Thomson, Derek. *The Companion to Gaelic Scotland.* Oxford: Blackwell, 1983.

Wain, John. *Samuel Johnson.* 2nd ed. London: Macmillan, 1980.

Ward, A. W. and A. R. Waller. *The Cambridge History of English Literature.* 15 vols. New York: Putnam, 1907–1933.

Watson, Roderick. *The Literature of Scotland.* Macmillan History of Literature. London: Macmillan, 1984.

Wittig, Kurt. *The Scottish Tradition in Literature.* Edinburgh: Oliver & Boyd, 1958.

ONE THOUSAND COPIES OF THIS CATALOGUE

HAVE BEEN SET IN ADOBE CASLON TYPE AND PRINTED

AT THE STINEHOUR PRESS IN LUNENBURG, VERMONT.

DESIGNED BY JERRY KELLY.

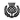